HANDSWORTH & PERRY BARR

THROUGH TIME

Eric Armstrong *&* Vernon Frost

AMBERLEY PUBLISHING

Acknowledgements

Two books in particular have helped us with the preparation of this book: Clegg, Chris and Rosemary, *The Dream Palaces of Birmingham* (Chris and Rosemary Clegg, 1983) Victor J. Price, *Handsworth Remembered* (Brewin Books, 1992). A warm 'thank you' is extended to unknown Birmingham passers-by and shopkeepers of various ethnic backgrounds, who showed courteous interest in our project and who readily volunteered information. A special 'thank you' is due to Miss E. Insch OBE, headmistress of Rose Hill Road School, her staff and pupils for the fine photographs they supplied and to Rosemary Stafford for her assistance with the research. We are also grateful for the pictures loaned to us by Handsworth Grammar School Old Boys Football Club.

First published 2010

Amberley Publishing Plc
Cirencester Road, Chalford,
Stroud, Gloucestershire, GL6 8PE

www.amberley-books.com

Copyright © Eric Armstrong & Vernon Frost, 2010

The right of Eric Armstrong & Vernon Frost to be identified as the Authors of this work has been asserted in accordance with the Copyrights, Designs and Patents Act 1988.

ISBN 978 1 84868 908 4

British Library Cataloguing in Publication Data. A catalogue record for this book is available from the British Library.

Typeset in 9.5pt on 12pt Celeste.
Typesetting by Amberley Publishing.
Printed in the UK.

Introduction

Like many small, rural settlements of the day, Handsworth featured briefly in the Domesday Book of 1086. Broadly speaking, Handsworth's hamlets and farms remained much the same for several centuries, rural and unremarkable. The area did not feature, as did neighbouring Aston, in the English Civil War of the seventeenth century (1642-48). And Handsworth was never to become known as the birthplace or home of a pre-eminent writer, artist or musician. But as regards engineering and metalworking, that was a very different matter as will be seen.

In 49 BC Julius Caesar, with his army, crossed the boundary stream called Rubicon in pursuit of conquest and the spoils of war. Some 1,800 years later, Matthew Boulton crossed Birmingham's Hockley Brook boundary into Handsworth to make what proved to be engineering and industrial history.

Matthew Boulton, the enterprising son of a successful Birmingham button maker in Snow Hill, had a large factory of advanced design, built on the Soho site near Hockley Brook. Through the digging of a short canal, this 'Rubicon' brook eventually became the power source for the Soho Works opened in 1762. With the help of James Watt, who vastly improved the efficiency of the steam engine, the Soho Works probably became the largest factory in Europe, '...a showpiece, visitors from far and wide coming to see the innovations made by Boulton.' (Zuckerman & Eley) The production process itself was novel, workers in separate workshops being involved in a single aspect of the manufacture of a wide range of metal goods, including – door handles, candlesticks, lamps of every kind, carriage fittings. At one time, nearly one thousand workers, men, women, and children were employed by the firm.

Boulton, Watt and Murdoch (father of gas lighting) all made their homes in Handsworth, Boulton's remaining to this day. The three men were deep thinkers as well as successful doers. In 1766, the Lunar Society was founded, a local organisation devoted to the study and

promotion of science, business and industrial production. 'Lunar' related to the practice of members meeting every four weeks on the night of the full moon – thought to help them on the way home. In addition to Boulton, Watt and Murdoch eleven other eminent men joined this think-tank. Among these were Dr Joseph Priestley, a famous chemist, discoverer of oxygen, Josiah Wedgwood, Dr Erasmus Darwin, grandfather of Charles. Eight of the group became elected Fellows of the Royal Society. Lunar meetings were held in members' homes.

Building on the impetus for industrial change, generated by the Soho Works, and other enterprises, Birmingham rapidly turned itself into 'the workshop of the world'. For more than a century, new factories, workshops and associated industrial buildings sprang up in parts of suburbs such as Witton, Aston, Small Heath, Washwood Heath. During the early twentieth century, large factories appeared on parts of the city's perimeter, e.g. Dunlop's to the north, Austin's, Longbridge to the south.

As Birmingham expanded, so did the population of residential Handsworth. In 1871, Handsworth's population numbered 14,359. Many sturdy late Victorian and Edwardian houses were built, mostly in terraces, and by 1911, the population had risen to 68,610. During the 1930s, new houses appeared on a few remaining fields and plots of land, the largest development being in the Cherry Orchard and adjacent areas, formerly farmland.

The increases in the population figures had far less to do with the birth rate than the search for a job and a home. With these goals in mind, people from all over the country moved to Birmingham and Handsworth. Then from the 1950s onwards, immigrants arrived in large numbers from the wider world, notably, the West Indies, India and Pakistan.

Between the world wars and even before, Jock, Taffy, and Paddy had been absorbed into the workforce and local community with, on the whole, good-natured tolerance and leg-pulling banter. Such homely behaviour was still needed post 1950 but became largely stifled by the sheer weight of numbers and radical differences in appearance, speech, culture and religion. Social tensions were inevitable. But by largely following that traditional policy of 'muddling through', a much-improved situation has been achieved. Younger generations seem likely to be more open-minded. Handsworth may well become a 'rainbow suburb'. Maybe it already is? Because a suburb is an aggregation of very many much smaller communities, the illustrations in this book are presented in a topographical way, and not by clusters of themes such as churches, schools, cinemas, pubs, shops – and curry houses!

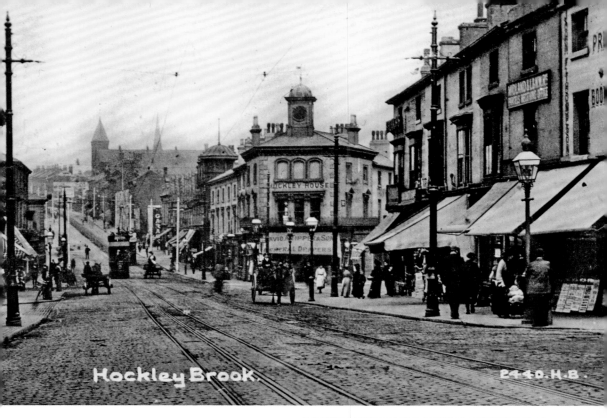

Hockley Brook. 2440.H.B.

Hockley Brook to Soho Hill, Handsworth
That 'Rubicon' ran underground by the tram, a cable car to be exact. The apparent central rail was a duct along which a steel cable ran continuously. The car was attached by a gripper to the cable and could be detached at the designated stops. Introduced in Birmingham in 1888, a cable car service worked from Colmore Row, in the city centre, to Hockley Brook. A year later the route was extended to the New Inn pub, Holyhead Road, Handsworth. The service was replaced in 1911 by electric trams. Today, because of the massive flyover and associated complex road conditions, the viewpoint of the postcard cannot be reached. But a modern sculpture near the top of Soho Hill resonates well with 'change in Handsworth', a central theme of this book. A local artist, Saranjit Birdi is the sculptor of 'Under the Sun' regarded as 'a symbolic gateway to the area', an area much concerned with regeneration.

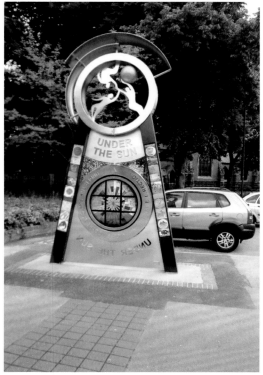

5

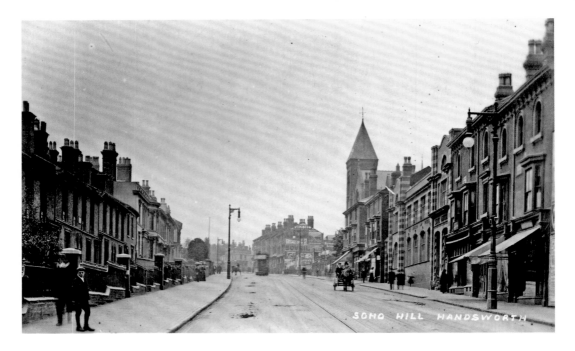

Soho Hill

Near the top of this hill, 'Matthew Boulton territory' is to be found, namely Soho House (see p. 8), Boulton's home close by the famous former manufactory. Over time, various manufacturers occupied premises shown on the right of the postcard. These included Adie Brothers, world-renowned silversmiths. Two men, right, are just passing a factory that produced studs and cuff links in a building that can be seen in the 2010 photograph, in red and pale yellow brick. Something of the new heritage can be seen left, part of the Hockley flyover and right, part of an imposing gurdwara, a Sikh temple.

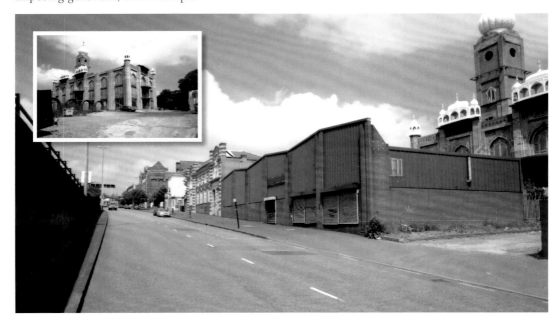

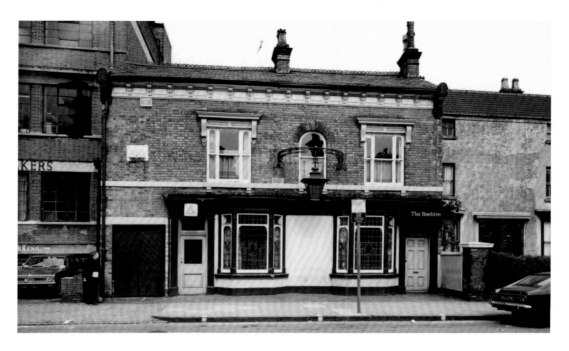

Soho Hill

Above is a 1971 photograph of The Beehive pub, a symbolic beehive being fixed above the left hand door. The photograph below shows that some attempts were made to have this M & B pub move with the times by providing pool and food. But the building has clearly been boarded up for some appreciable time; note the wear and tear. More encouraging signs are visible next-door, 'Open to Trade and Public' by 'High Tec' – but what is to be made of 'Body Sculpture'?

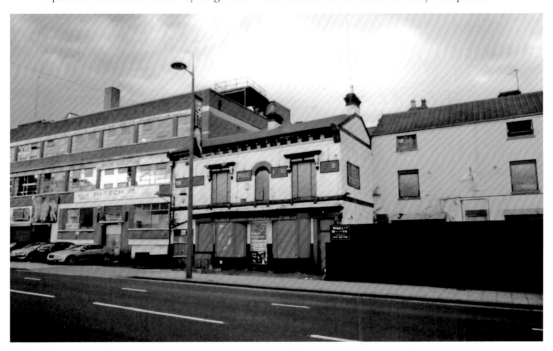

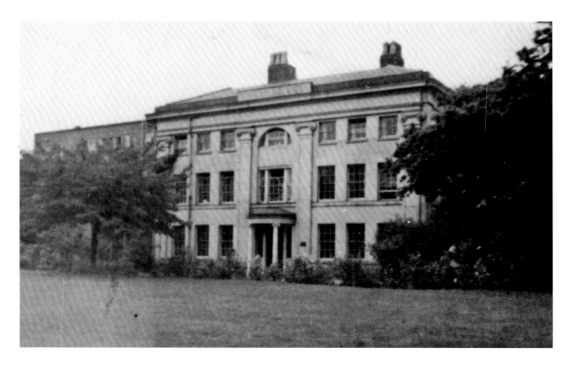

Soho House

This fine mansion became historic not for architectural, aristocratic or financial reasons but for being the home of Matthew Boulton. Built for this great entrepreneur in 1766, Boulton lived there until his death in 1809. As mentioned earlier, Soho House became one of the regular meeting places for the Lunar Society. The house now serves as an industrial museum, a property that looks its best on a sunny day.

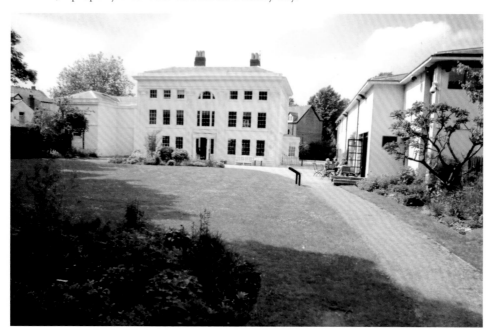

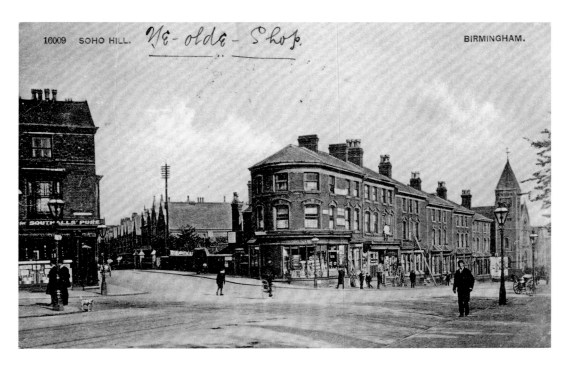

16009 SOHO HILL. *Ye-olde-Shop.* BIRMINGHAM.

Soho Hill

'Ye-olde-Shop', seemingly a grocer's, stands at the corner of Wretham Road. To the right, at first floor level a window cleaner is perilously earning an honest crust. Further to the right is a Congregational Chapel built in 1892. In the interests of traffic control Wretham Road has become a cul-de-sac, but at least a bench has been provided for those who wish to watch the world go by.

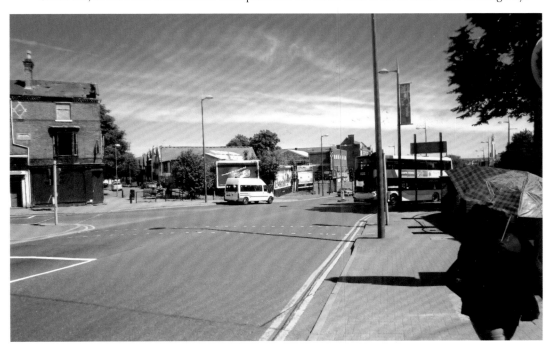

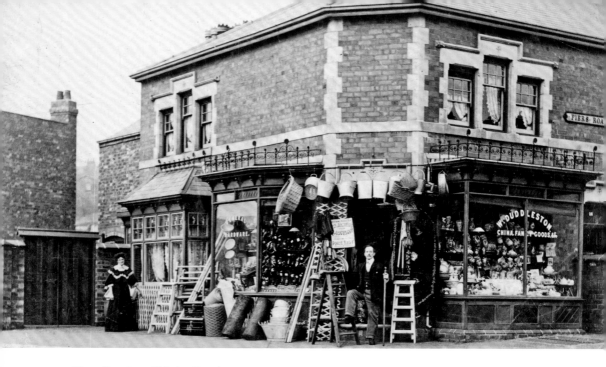

Piers Road – off Soho Road

The name of the above short road features on both photographs. Mr W. Duddleston rightly displays pride in his almost extravagant 'General Hardware, China, Fancy Goods' – and other 'oddments', including shoes? His presumed helpmate, wearing her Sunday best perhaps, also looks well pleased. The shop's current successor makes his own vivid mark, offering a far wider range of services than the old time barber's who indicated their shops by red and white striped poles. 'Suffera From Nutten 2 Something', along with the colour suggests a touch of Jamaican good humour.

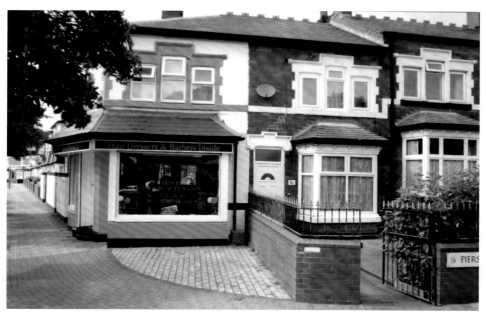

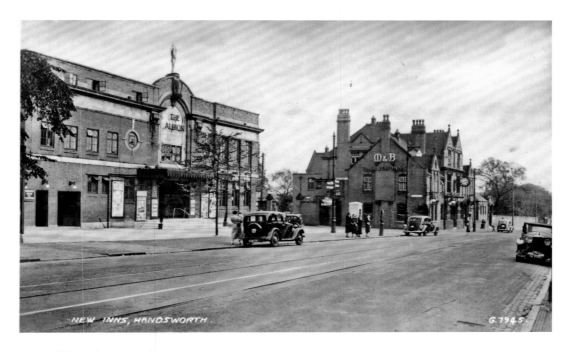

NEW INNS, HANDSWORTH. G.7945.

Albion Cinema and New Inns

Shown above are two major Handsworth landmarks of their day in Holyhead Road. The cinema, opened in 1916, was later enlarged to the size shown and self-styled as 'Handsworth's Home of Entertainment. We offer you the pick of the World's Best Films'. On the corner of Sandwell Road stands the New Inns, a premier league M & B hostelry. The cinema has been replaced by a modern block of rented flats with Ladbroke's occupying the ground floor. As for the pub refer to next page.

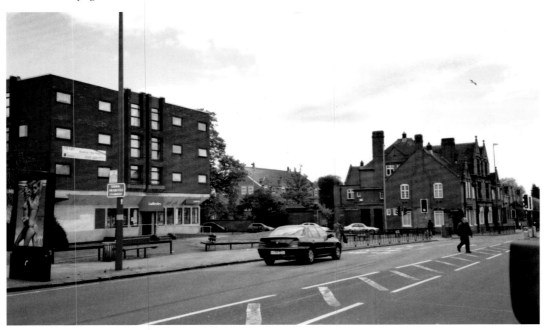

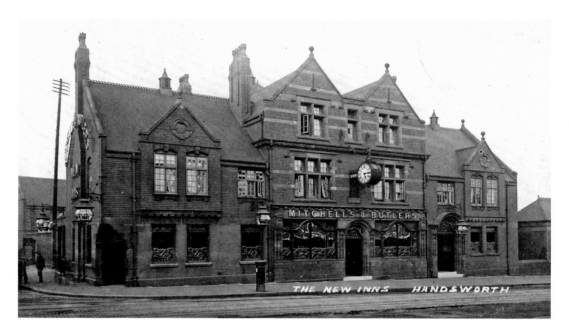

New Inns

For many years, earlier pubs of the same name had traded on this site. In 1898, the inn was sold to major brewers Mitchells & Butlers, who enlarged the building and greatly improved its facilities. The New Inns became the place in Handsworth for holding a memorable 'bit of a do'. Also a well-known tram stop, first for cable cars and then electric trams. The shell of the building remains and the interior has been converted into flats by the Midland Heart Housing Association.

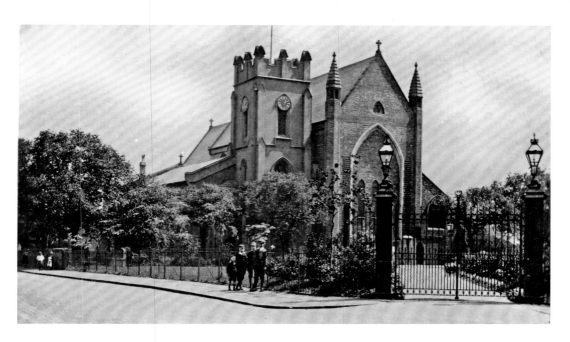

St James Church, Crockett Road

The land for this church was gifted by Mr John Crockett, owner and landlord of the New Inns Hotel. Built and opened in the late nineteenth century, the church underwent several enlargements as Handsworth's population grew. Situated on the corner of Crocketts Road and St. James Road, in addition to Sunday services a Eucharist service is held on Thursdays. The present vicar is the Revd Dr David Isiorna.

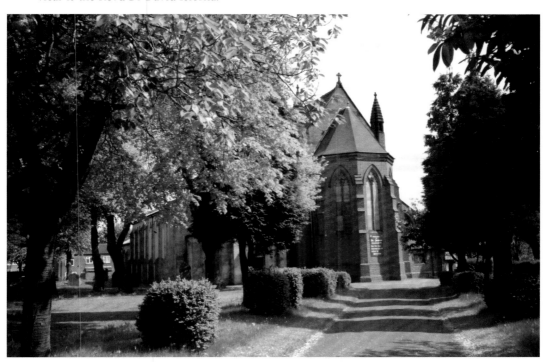

Regal Cinema and Gurdwara

The Regal opened in 1929 and it was Birmingham's largest suburban cinema, seating over 2,000 people. The cinema's opening programme was something of a sensation being the first showing in the city of 'talkies'. On the site of where it once stood at the corner of Booth Street and Soho Road is a large branch of the giant German supermarket business, Lidl. Of more scenic interest is the handsome building across the way in Oakland Road, a new gurdwara nearing completion.

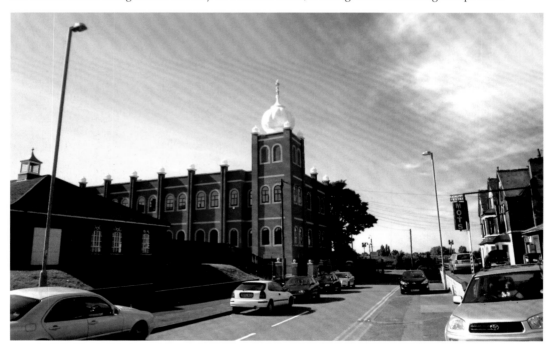

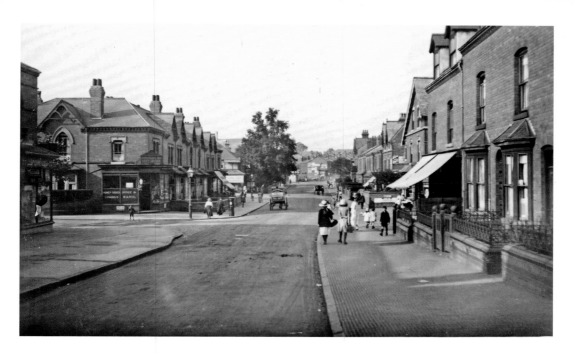

Rookery Road

On the corner left, 'Post Office & Savings Bank' can be made out. More trading is going on nearby. Further evidence of this activity can be found, for example, in a 1907 directory. This shows that from 74 to 104 Rookery Road, thirteen properties were listed, ten being occupied by traders and other workers including: 'beer retailer, pork butcher, tripe dealer, dressmaker', not forgetting 'insurance agent and midwife'. In 2010, groups of shops at irregular intervals are still to be found.

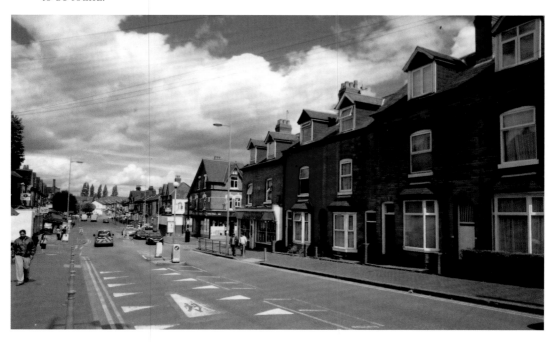

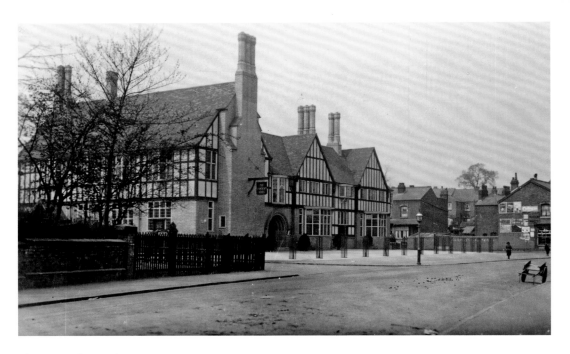

The Farcroft Hotel

At the corner of Albion Road, this 1922 building of presumably mock Tudor design was highly popular in the 1920s and '30s, attracting lovers of jazz bands, dance bands, and ballroom dancing. In modern times, 'Bar-B-Qs' are advertised along with 'Refurbished Function Room Now Available For Hire. Seating Capacity Up To 300 People.' Is the phrase 'having a knees-up' still in use?

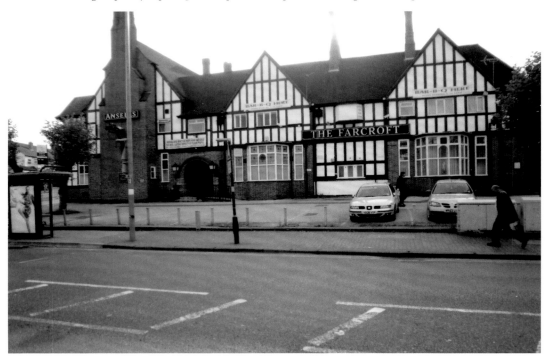

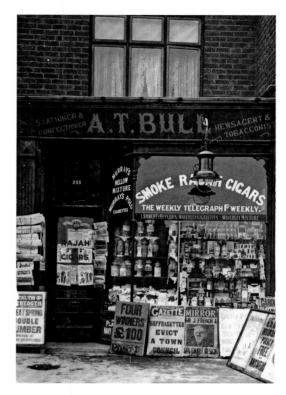

Rookery Road No 233

A newsagent-tobacconist's, typical of
its day – proprietor Alex Thomas Bull.
Almost certainly the year is 1915. Field
Marshal Sir John French was in command
of the British Expeditionary Force in
France. Criticised for being indecisive,
he resigned from office in 1915. It was
probably the *Birmingham Gazette* that
carried the intriguing news about militant
Suffragettes. As for 'Health & Strength' left,
research is needed. Not so now with 'Nail
Extensions' at fifteen quid a time. What a
change in disposable incomes!

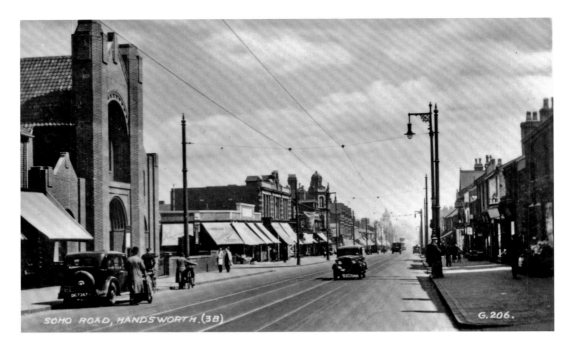

Soho Road

Like the title of a popular between the wars song, 'On the Sunny Side of the Street' all the shops left seem to have their blinds drawn down to protect their window display goods. The nearby corner shop is a branch of the Birmingham Co-operative Society, well represented throughout the city. Next door stands the Cannon Street Memorial Baptist Church. It was opened in 1930 to replace a city centre church, in Cannon Street, demolished for road development purposes. The Co-op shop has been replaced by a coach station.

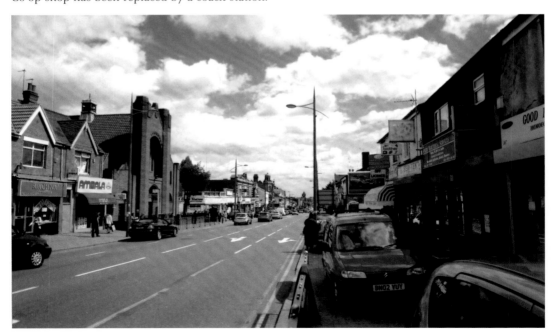

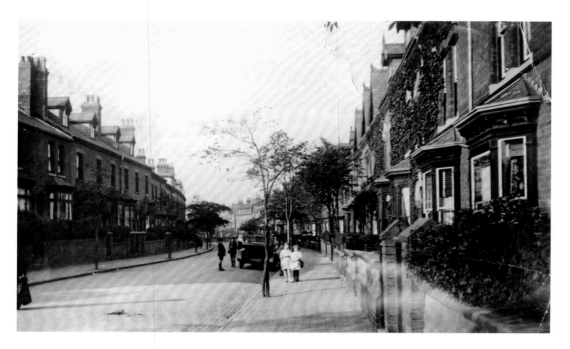

Murdoch Road

One of the many residential roads branching off Handsworth's High Street. Again, another road is named after one of the illustrious trio already mentioned. For whatever reason, it was not uncommon to find houses on one side of the road higher and grander than those opposite. What was a novelty 'then' is all too commonplace 'now', i.e. the motorcar. The postcard is franked 1926; note the boys' interest, so different from that of the girls'. Plus ça change...?

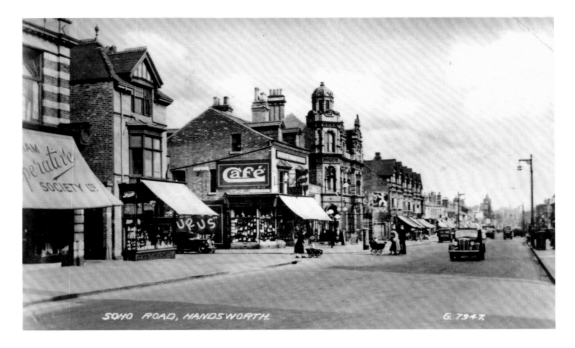

Soho Road

In some ways the two photographs are broadly similar, especially in relation to the shape of buildings, but a branch of the Punjab National Bank has replaced the Co-op shop and Nails World would have mystified inter-war shoppers. The URUS of 'yesterday' signifies 'PURUS', a bread shop. In the distance can be seen the clock tower of the Council House, a useful marker.

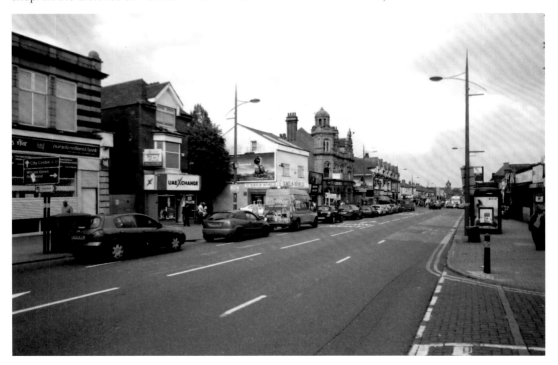

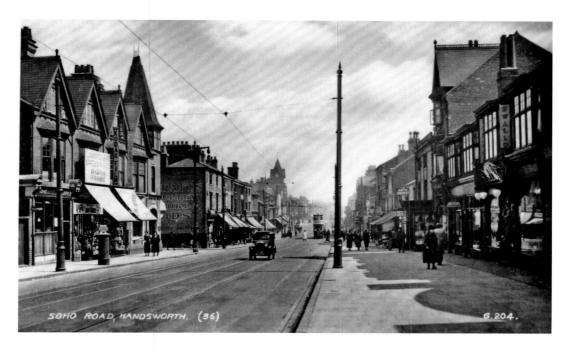

Soho Road

Again, a number of similarities in features of the buildings can be identified. But the old post office has closed with a new one opened on the opposite side of the road where, surprisingly perhaps, the broad pavement has retained its width. On the postcard, close by the tram, stands a figure wearing a long white coat, quite possibly a traffic policeman. The clock tower is now much nearer than on page 20.

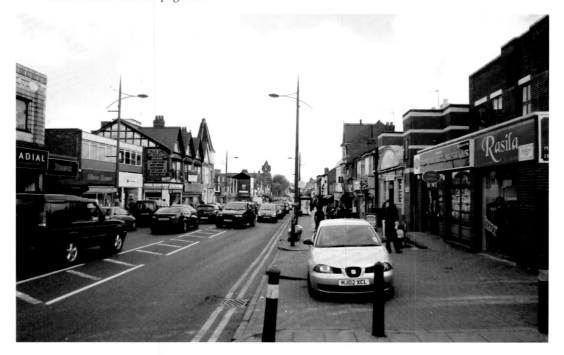

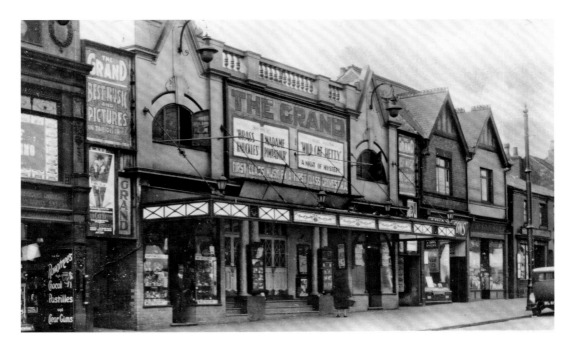

The Grand Cinema, Soho Road

Although this cinema opened before the First World War, it had only a relatively short life. It did not convert from silent to talkie films and failed as a result. The titles of the silent films shown on the postcard seem to promise excitement, added to which is the advertised 'First Class Music By A First Class Orchestra'. Perhaps an ensemble of five, probably less. The building underwent various changes and uses to emerge as shown.

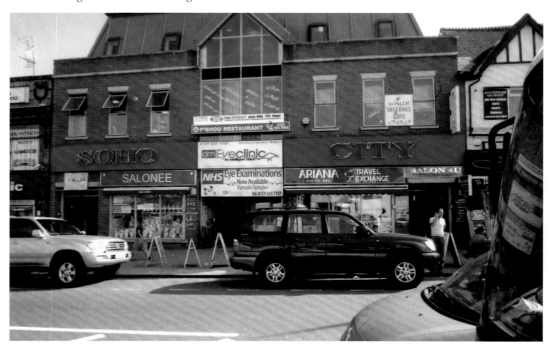

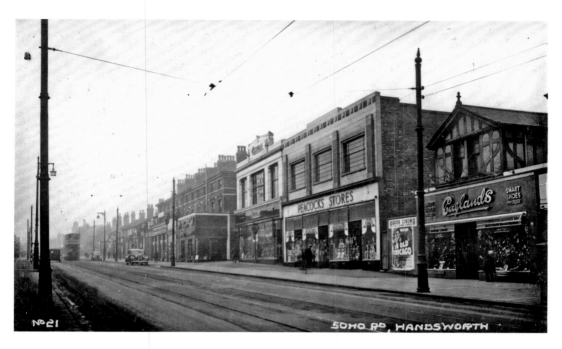

Soho Road – 'Looking Back'

The postcard illustrates the growing number of chain store branches opening on high streets. On the left of Peacocks Stores (Woolworths rivals) is a branch of Burtons, men's outfitters, and on the right an England's shoe shop. The present shops are housed in the same buildings. What is missing between Adial and Shoe Zone is a colourful poster like that shown by the Albion cinema (see p. 11) advertising *In Old Chicago*, a 1938 film much praised for its spectacular effects simulating the actual fire of 1871 when the city was almost destroyed.

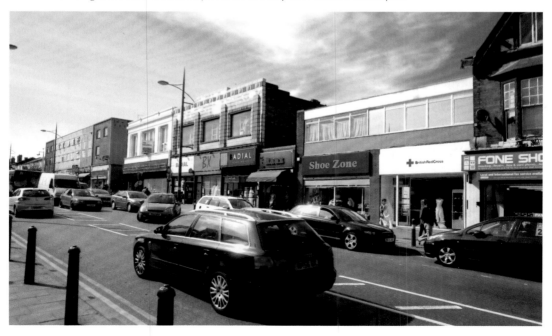

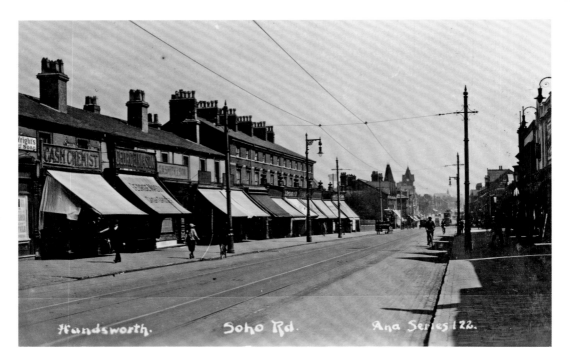

Soho Road

Above, the emphasis is on cash and below, plastic. On the postcard the first shop is a 'Cash Chemist', the second a branch of George Mason's, multiple grocer's, also requesting cash. It was usually easier to obtain tick (credit) from a one-man corner shop. Cash was literally quite a heavy matter, 240 'brass' pennies to £1.

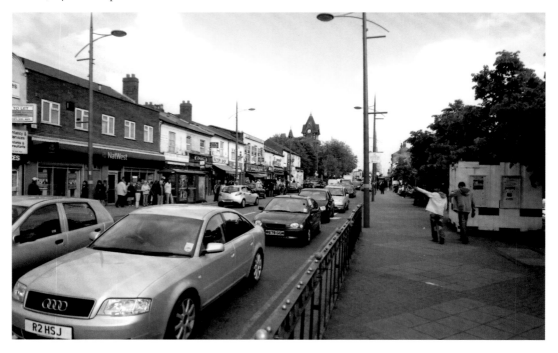

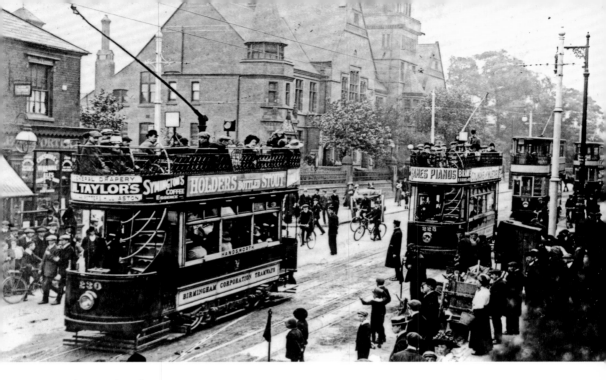

Soho Road and Trams

A truly red-letter day for Handsworth bigwigs and residents alike – the day in July 1911 when the suburb's first electric trams appeared. The car left is nearing the corner of Stafford Road, heading in the direction of Soho Hill. The large building is the Council House and library, a fine example of late Victorian redbrick Gothic, dating back to the late 1870s. At one time, at the corner mentioned stood a pub with an unusual name, 'Frighted Horse' now corralled by scaffolding. From the outset, tram operators, private and public, had realised that revenue could be raised from advertisers.

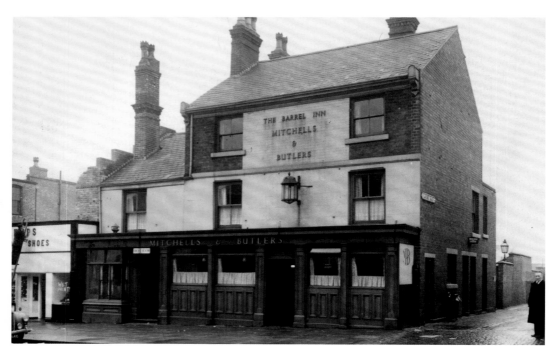

The Barrel Inn, Soho Road

Talking of pubs, this one, on the corner of Louise Road, has obviously fared much better. The Barrel of today looks spruce and inviting. There are interesting neighbours too – a tidy 'greengrocer' with a neat shopfront display, and a bookies. Beneath 'Our Yaar...' can be read 'The FREE Asian Directory'. The postcard photograph was taken on 1 September 1957.

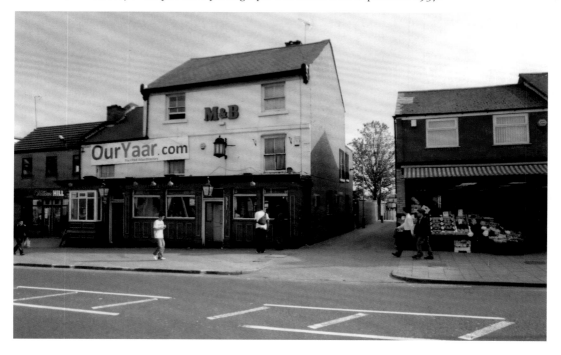

Soho Road – No. 137

Once seen in real life, probably never forgotten. The stuff of nightmares for some, objects of envy and desire for many more. A directory of 1907 prosaically records, '137 Bruckshaw Wm, butcher'. Next-door neighbours were '135 Foxhall Henry, gasfitter, 139 Orchard James, boot dealer'. A century later, what a transformation in the preparation and presentation of meat. Mirchi, Asian-owned, exemplifies the present day food favourites, including, 'World Cup Special Offers'. As for 'Wah Wah' – something different from a musical expression?

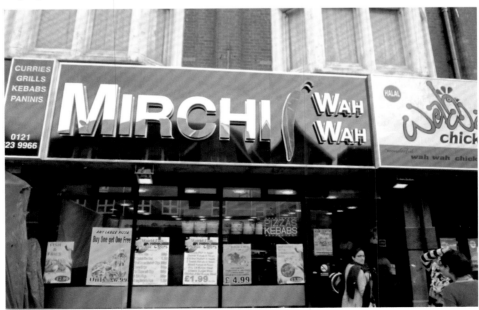

Holliday Road – No. 33
A southern offshoot of Soho Road. The prevailing practice of neatly arranged net curtains is favoured but something is askew with the garden gate. Perhaps a mislaid spirit level?! The entry was and remains essential for access to 'round the back' in blocks of terraced houses, for residents, visitors, the coalman; and, by custom and practice for at least half the last century, for courting couples to exchange goodnight kisses, and for passers-by to take temporary shelter in, from air raids, 1940-42. Now satellite dishes convey simulation of stimulation.
(N.B. many such entries are now gated.)

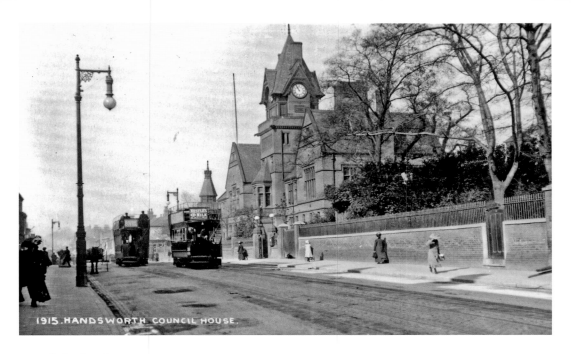

1915. HANDSWORTH COUNCIL HOUSE.

Soho Road

The absence of overhead electrical wiring indicates that the trams are, in fact, cable cars, their open tops affording good viewing in fair weather but some reluctant passengers in foul. Some of the detail of the Council House from its eastern side can be seen. Today that building is virtually shrouded by foliage and new buildings have been built nearby. There are new shops too, including one signed 'Bollywood'. Is the shopper saying, 'I'll have that one please'?

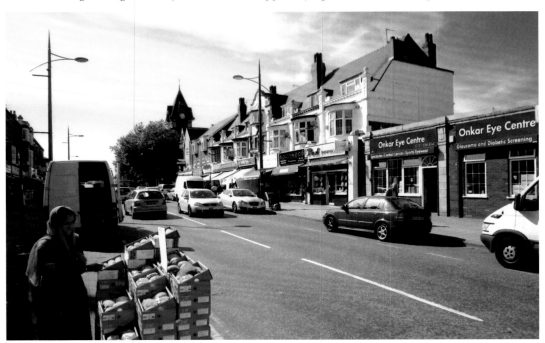

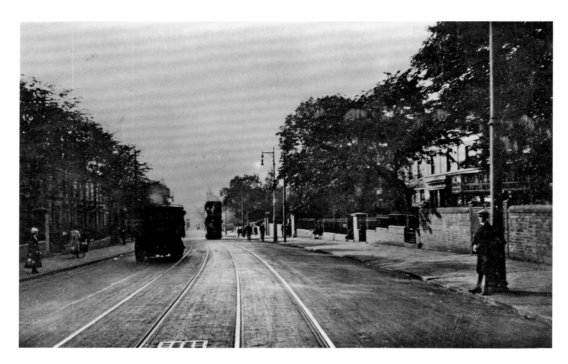

Soho Road

From the Council House towards Soho Hill, Soho Road became less commercial and more residential, as the postcard shows. That pattern has been broadly maintained except for the striking inclusion of a Sikh Temple, a gurdwara named after the founding father of the Sikh religion, the Guru Nanak Sikh Gurdwara. The tower forms part of a much larger building.

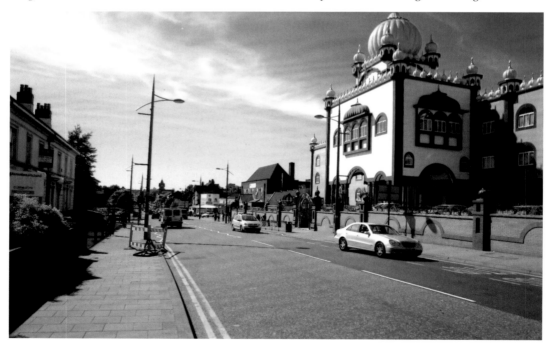

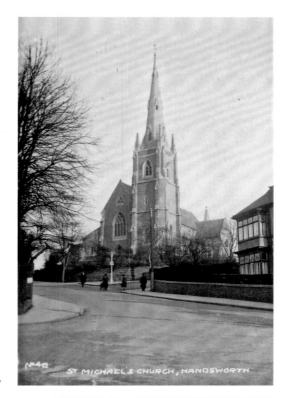

St Michael's Church – Soho

Although the two photographs are probably
a century apart, both convey a sense of
semi-rural tranquility but being just a short
distance from the top of Soho Hill, the
reality for today's church is very definitely
urban. Built in less than three years, St
Michael's was consecrated in 1855. The
tower and spire reaching a height of 160
feet, was added some years later.

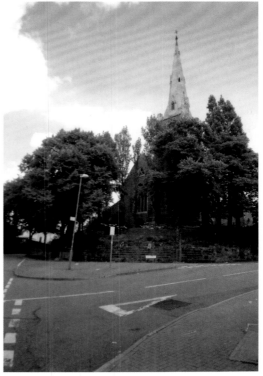

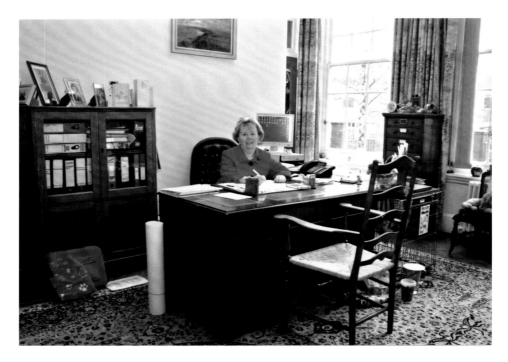

Rose Hill Road School – Headmistress

In 1911, three King Edward VI Foundation schools for girls amalgamated and moved into a new school building in the above road. This school became and has remained highly regarded and successful. Miss Nimmo, shown below, was the first headmistress and Miss Insch OBE (above) is the current one. More than 900 girls are on the school roll including nearly 250 in the sixth form. (From stern efficiency to relaxed efficiency, dare one say about compared photographs?)

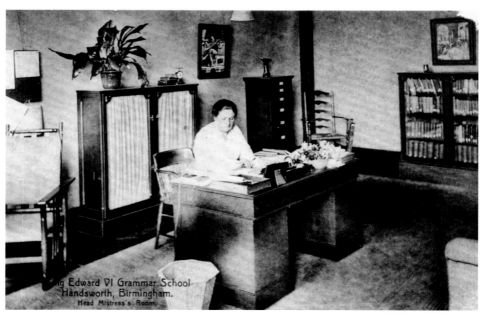

g Edward VI Grammar School
Handsworth, Birmingham.
Head Mistress's Room.

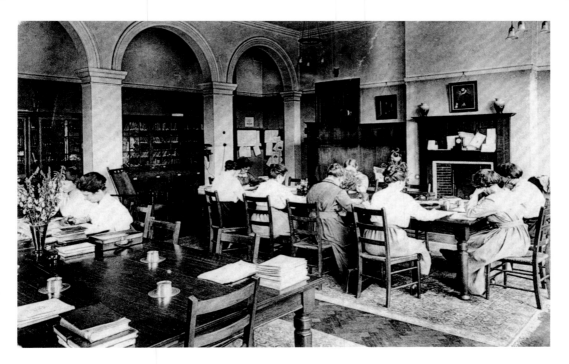

Rose Hill Road School – Staff Room

Although the scenes are ninety-nine years apart, some features of the room remain exactly the same. There's a lot to be said for certain types of continuity! Teachers in 1911 appear to have adopted one particular hairstyle, following fashion or are there more practical reasons? It is hardly likely that Miss Nimmo or the governors would have countenanced a male teacher in an all-girls' school. Now, at least seven men can be spotted, one aspect of the 'relaxation' referred to on the previous page.

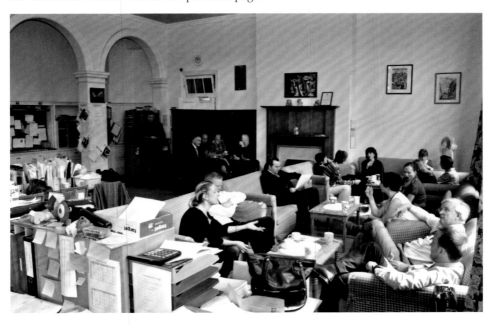

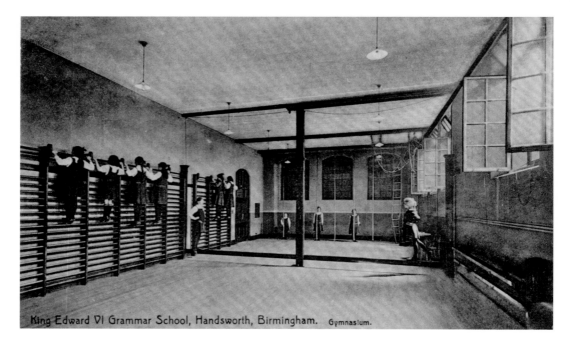

King Edward VI Grammar School, Handsworth, Birmingham. Gymnasium.

Rose Hill Road School – Gymnasium

No doubt in 1911 the gym was considered state of the art. But how much more spacious, lighter and brighter is the 2010 version. The long wall opposite the one shown is also made of glass panels. It is interesting that there is at least one piece of apparatus that links the old and the new, namely, 'good old wall bars' used for all manner of PT exercises, from the mild to the mildly vicious.

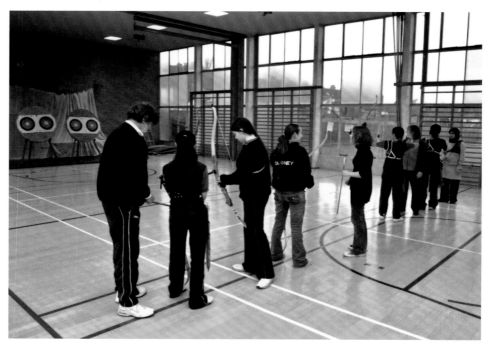

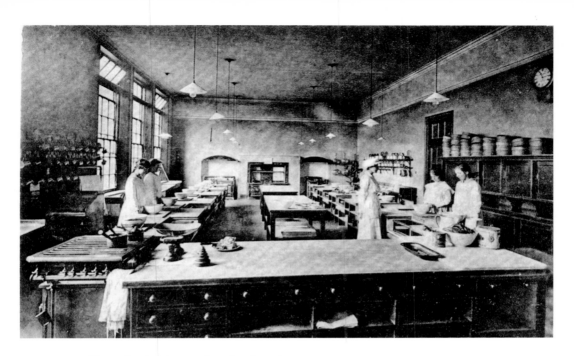

Rose Hill Road School – Food Technology Room

'Cookery Kitchen' is printed on the postcard, a room where the gas oven looks sufficiently sturdy for whatever task may come its way. Note the nearby scales and the pyramid of bulky iron weights. It would be interesting to compare the curriculums of present and past. In 1911, roly-poly pudding might feature and in 2010, various curries, plus scientific aspects of food and its preparation. The youngsters obviously have different ethnic backgrounds.

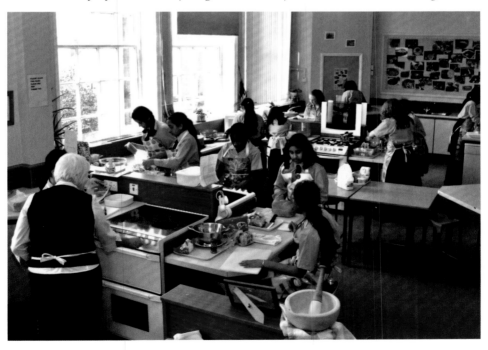

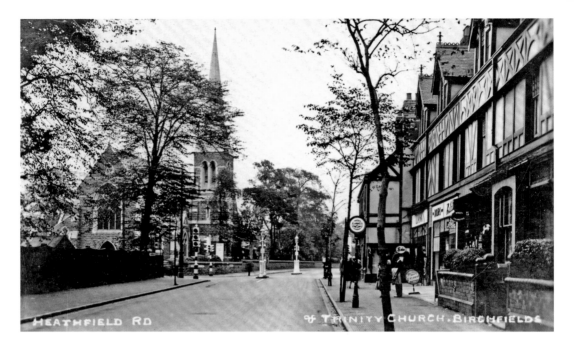

Heathfield Road

'Buses Stop Here By Request'. Catching the 29 or 29a bus from the above stop provided a trip into town. Since the Second World War, various radical changes have reshaped these crossroads – a road-widening scheme entailing the demolition of 'old' buildings and the erection of new structures, an ugly flyover and an attractive redbrick mosque, Jame Masjid (Main Mosque). Both can be seen as symbols of our devotion to road travel and the dramatically changed nature of the local ethnic mix.

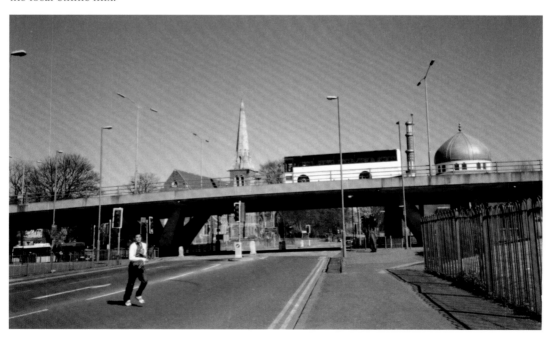

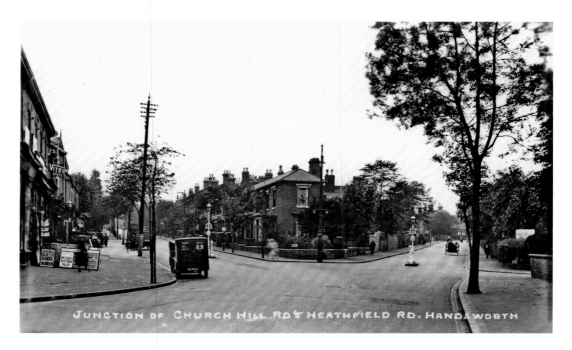

Junction of Church Hill Rd & Heathfield Rd, Handsworth

Heathfield Road

Correction: Heathfield Road runs left and Church Hill Road right. While there is little apparent physical change, the real interest of the comparison lies in the placards above. A newspaper advertises 'Dollfuss's Austrian Policy.' Dollfuss, a would-be dictator, became the Chancellor of Austria in 1932. In 1934, he was murdered by the Nazis. *John Bull*, a radical weekly magazine, seeks to excite our interest with 'A Queer School of Women'. Regretfully, the authors have no knowledge of the school mentioned.

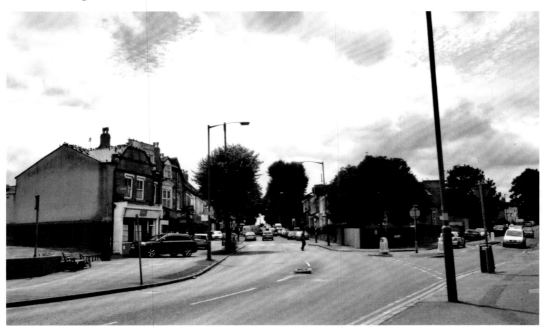

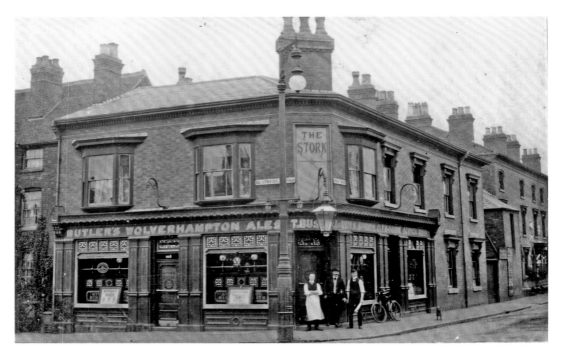

Heathfield Road – The Stork

This pub, nominally a hotel, still stands at the corner of Finch Road. At the time the postcard was photographed, *c.* 1907, Mr T. Bushill was the pub's landlord. The pub is still licensed but its corner entrance has gone, as have a goodly collection of chimney pots.

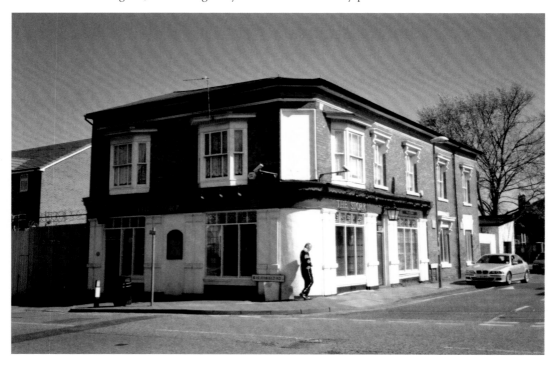

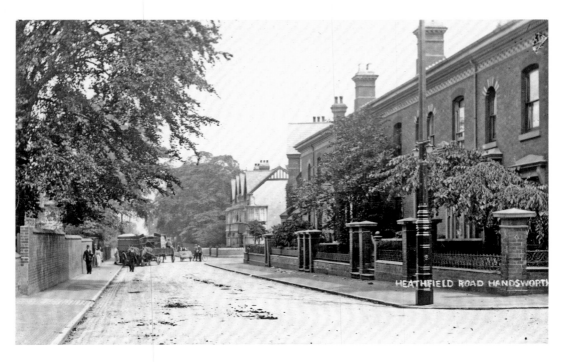

Heathfield Road

An ordinary road but one with far from ordinary connections. At one time, on the left, stretched the estate of James Watt. Neat new properties, some in James Watt Drive, have replaced those shown on the card. Around 1874, under a gaslight on this road, chapel-going young men, keen on cricket, decided to form a football team which became, in time, Aston Villa FC. The club's early home ground was in Perry Barr. It is pleasing to see that close to the roofs of the houses on the right, the chequered brickwork has been retained.

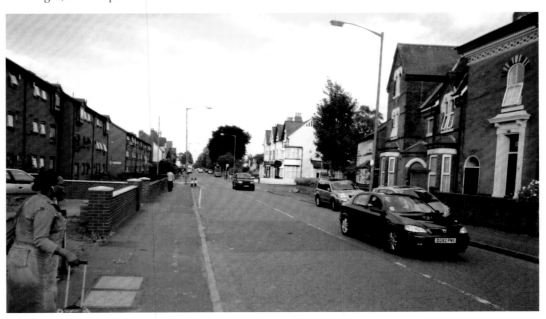

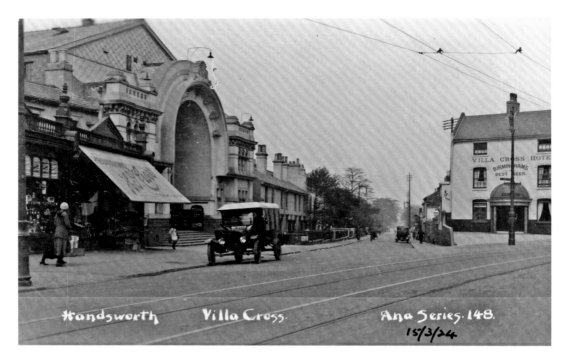

Handsworth Villa Cross. Ana Series. 148.
15/3/24

Villa Cross

At the junction of Heathfield and Lozells Roads stand two iconic buildings of Old Handsworth, the Villa Cross Picture House, opened in 1915, and a neighbouring hotel selling 'Birmingham's Best Beer'. The pub, rebuilt in the 1930s and later modified, has survived as a building but the 'palace of dreams' is long gone, replaced by a prosaic but useful car park for the adjoining 'Food Bazaar'.

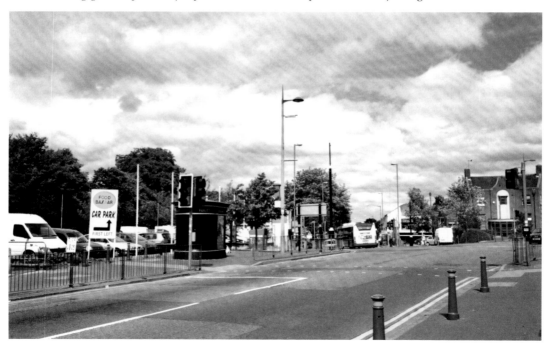

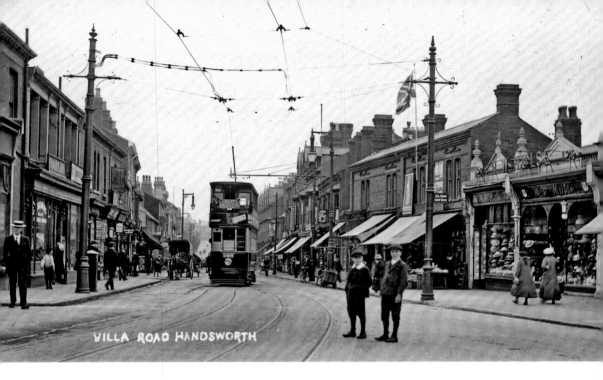

Villa Cross

Two lads resolutely turn their backs to the milliners while the ladies swivel their heads towards the fashionable headgear on display. This section of Villa Road formed a virtual paradise for keen shoppers and window-gazers. Tram car 369 is signed 'Lozells to Gravelly Hill'. This is a pre First World War postcard when hats mattered, and schoolboys were not exempted. Now, 'foreign' headgear prevails while exotic foodstuffs have achieved everyday status.

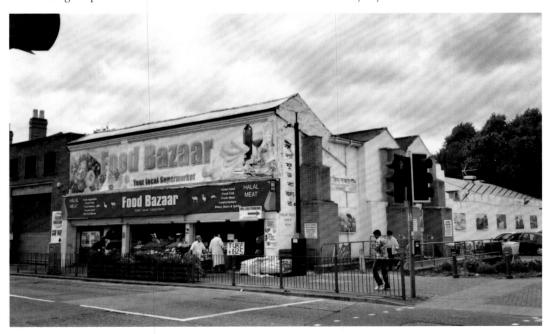

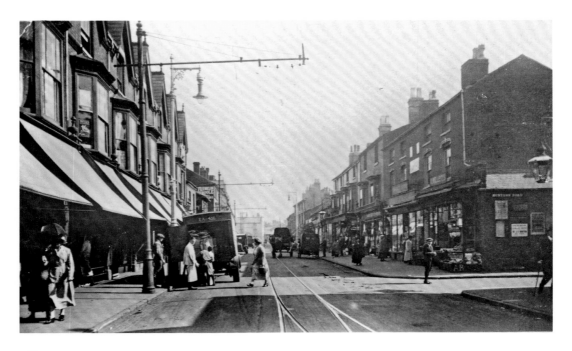

Villa Cross

At a distance, on the postcard below, written in 1924, can be seen the Villa Cross Hotel. The solitary lad, right, stands at the entrance to Hunters Road. Given the white jackets and aprons, the work going on at the back of the van could be to do with the delivery of sides of bacon to a grocer's shop. As for today, 'Halal Meat' is meat prepared in the manner decreed by Muslim law. Boisterous West Indian music issues from an open shop door.

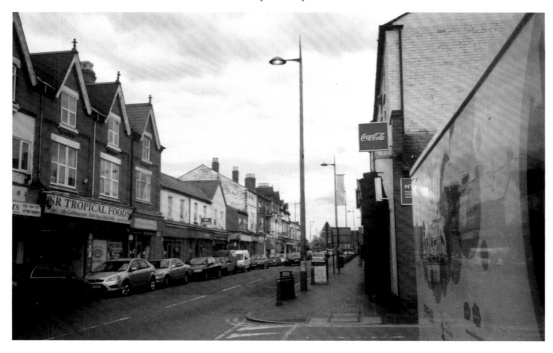

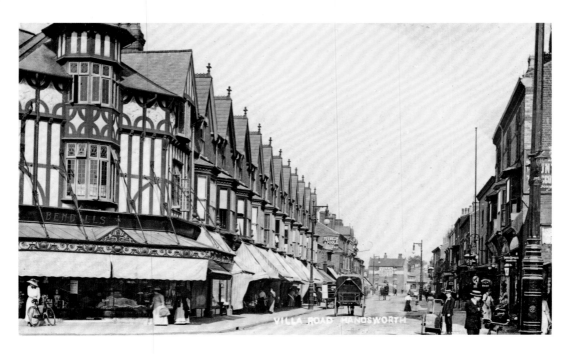

Bendalls Corner

In fine condition stands one of Handsworth's best known old landmarks, whether viewed on foot, or riding in a car, lorry or bus. This distinctive building, its design perhaps influenced by The Arts and Crafts Movement, housed in its early years a rather swish baker-confectioners, run by two sisters, by the name of Bendall. The handsome Edwardian buildings next door have also survived well, retaining their air of dignity no matter what commercial activities take place at ground floor level.

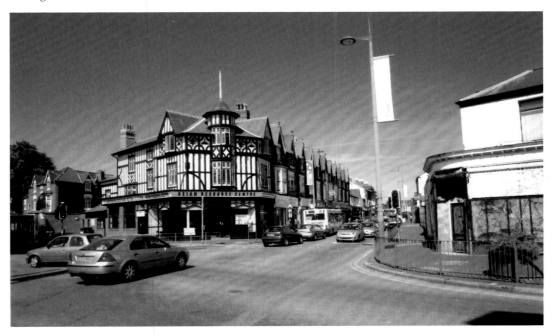

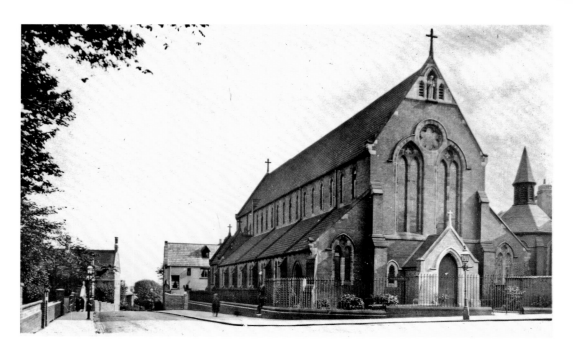

St Francis Church

This Roman Catholic Church, dedicated to St Francis of Assisi, was consecrated in 1900. Located at the corner of Wretham Road the church naturally has a close association with the convent, in the distance left in Hunters Road. The convent was opened in 1841.

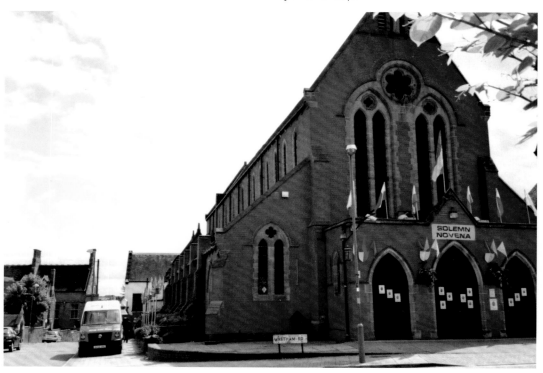

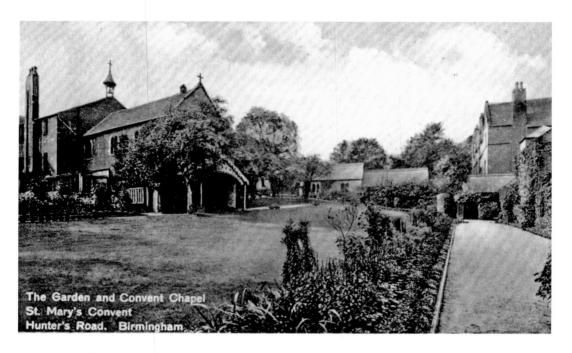

The Garden and Convent Chapel
St. Mary's Convent
Hunter's Road. Birmingham.

St Mary's Convent Gardens

After more than a century and a half the gardens still convey an atmosphere of tranquillity and reflection. Charity work has long been carried out by Sisters of Mercy. The convent is a Pugin building. Augustus Pugin (1812-52) was a talented English architect who made an important contribution to sculptures and decorative work for the new Houses of Parliament (1836-37). He converted to Catholicism during the 1830s.

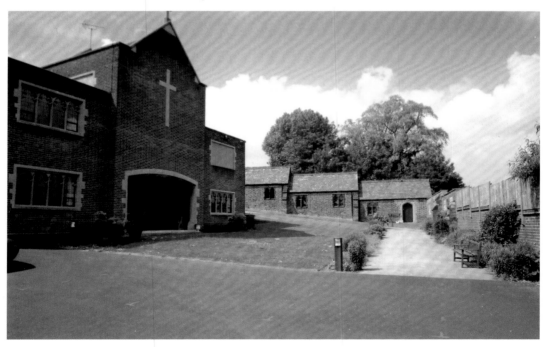

Hamstead Road

On a similar postcard has been written, 'is it not a pretty road?' A century ago, a house move from Hockley to Handsworth would have been regarded as an important step up the social ladder. The spire forms part of a large Baptist Church built in the 1880s to accommodate up to 800 worshippers.

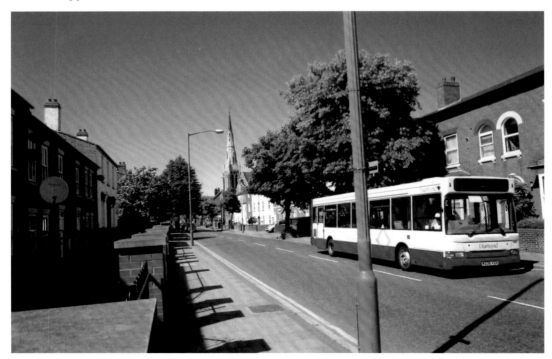

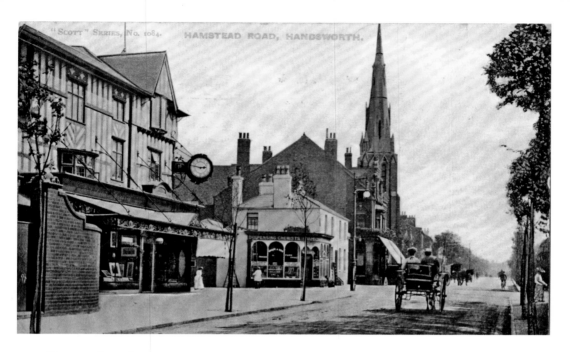

Hamstead Road

Bendall's Corner on a quiet, sunny afternoon – assuming the shop's clock to be accurate. Across the way is a 'Dispensing Chemists – Snape & Son'. These are the clip-clop days of pony and trap, horse buses and horse-drawn traffic generally. The postcard is franked 1909 and shows a horse-drawn van turning into the upper part of Villa Road. A 'livelier' situation prevails today.

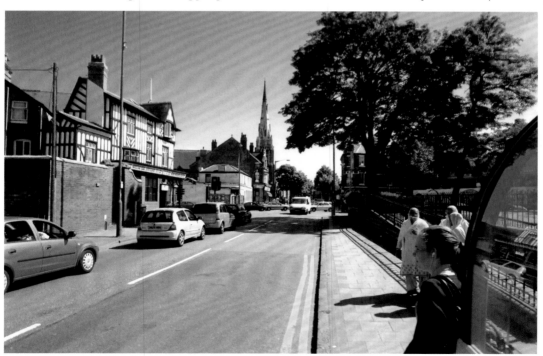

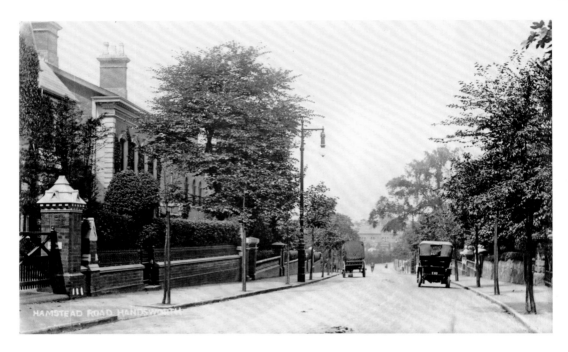

Hamstead Road

Between Bendall's Corner and Church Lane, a distance of about three quarters of a mile, Hamstead Road was home to one shop and two pubs. The remainder of the road consisted of good quality houses, a church, an Infant School, the boundary of a public park (Victoria) and some fields. In short, this was a prime residential thoroughfare with similar roads branching away on either side. In some ways, it still is, but at some cost to front gardens.

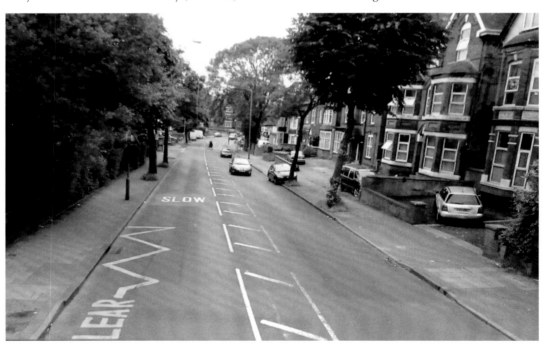

48

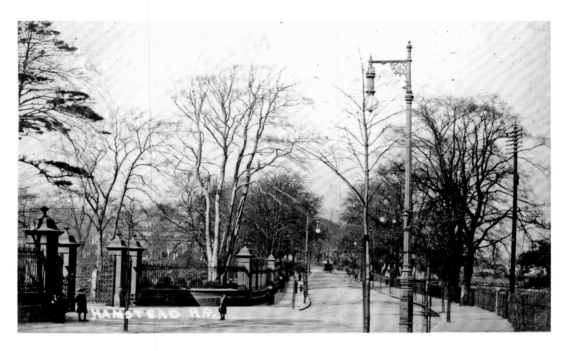

Hamstead Road

On the left, imposing gates stand open to one of the three original main entrances to Victoria Park, Handsworth. The open fields opposite once formed part of the Heathfield Estate on which was built Heathfield Hall, home of James Watt. During the 1930s, a line of modern semi-detached houses was erected behind the trees right. (Postcard franked 1911). As can be seen, those 1930s houses still enjoy sizeable front gardens.

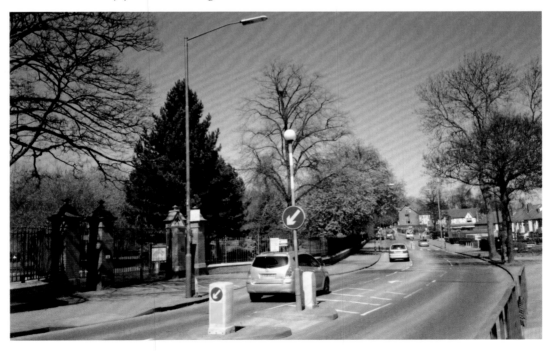

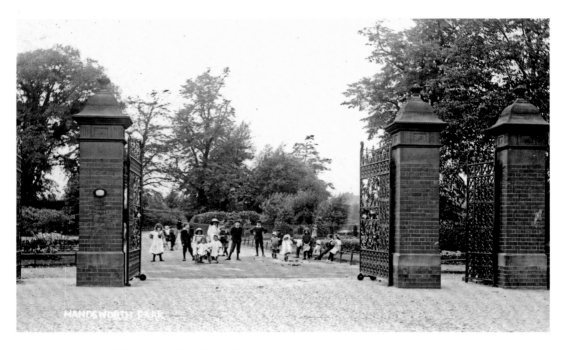

Handsworth Park (formerly Victoria Park)

Early twentieth century children eagerly await – who knows? Perhaps they are just posing for the photographer. The massive iron, elaborately scrolled gates constitute a work of art. Despite their size and weight, the gates could be turned relatively easily, thanks to the small metal wheels (visible) running on smooth metal rails. The newer gates, although less ornate, are still pleasingly fit for purpose.

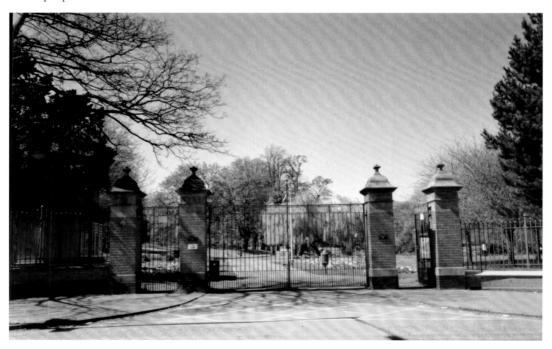

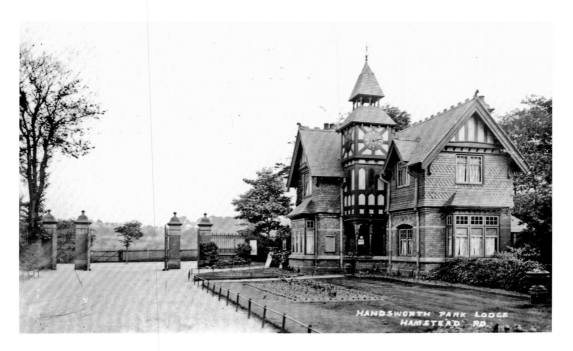

Handsworth Park

'It is a job to find a pretty pic to send you as the beauty spots in B'ham are rather rare.' Such was the opinion, in the form of a PS of one Eustace in 1932. The fields opposite to the lodge, ripe for development, are plain to see. It is challenging to spot the differences in the lodge despite the passage of seventy years or more. But the clock of 2010 was not telling the right time!

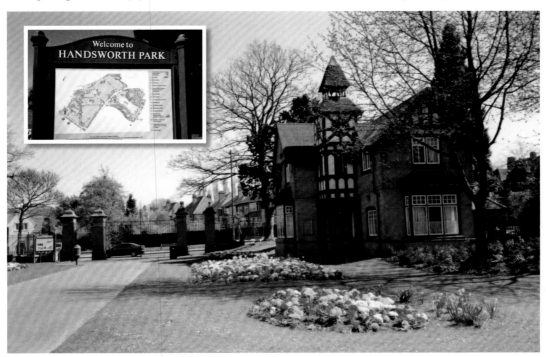

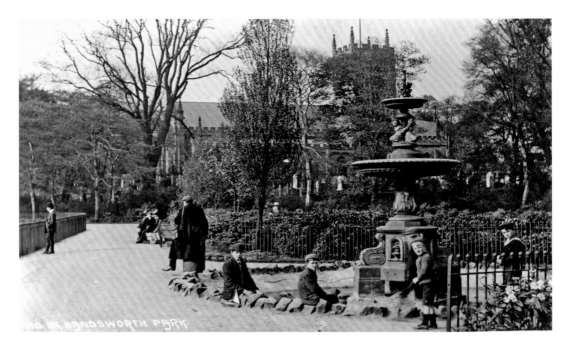

Handsworth Park

When opportunities arose, scores of urchins would flock to this fountain. Some, from a later generation, would run, at reckless speed, around the basin, pretending to be a daredevil racing driver on the steeply banked Brooklands racing track. Freddie Dixon perhaps or... In the background stands the Parish Church of St Mary's. (Postcard franked 1909). And now, perhaps, no more juvenile larking about, the fountain having been replaced by a refurbished 'fountain' from its original site near the Grove Lane entrance to the park.

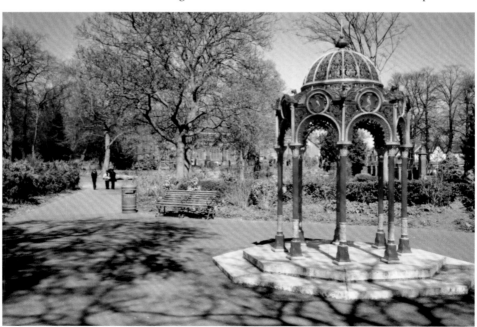

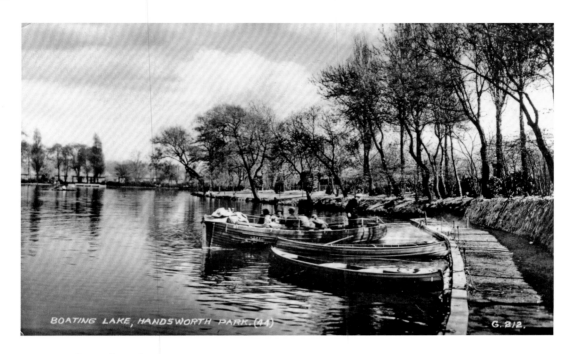

BOATING LAKE, HANDSWORTH PARK. (44) G.212.

Handsworth Park

As well as motorboat trips around the lake, rowing boats could be hired, as could single sculls, known as skiffs. A wooded island, out of bounds for boats, stands roughly in the centre of the pool and a fine boathouse and slipway stood near the boats shown. (Postcard franked 1936). A modern boathouse has replaced the old, and pleasing landscaping has been carried out, subtly conveying the impression that the area looks more like part of a fine estate than a municipal park.

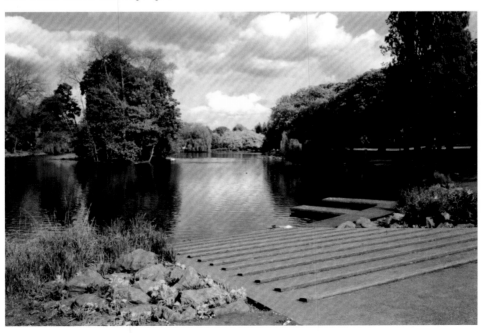

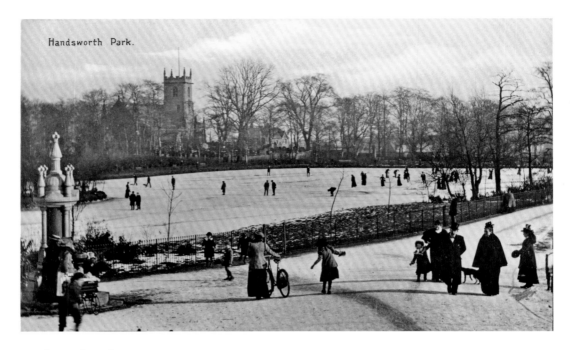

Handsworth Park.

Handsworth Park

A postcard written on 6 April 1916, but probably a pre First World War scene. A joyful occasion of a kind not so often witnessed in recent times. On the left, and possibly bearing icicles, is an ornate drinking fountain with its heavy metal cup securely chained to the basin. The fountain was presented to the park at its opening in 1888 to the public. Note that the iron railings have disappeared, the grass verges sloping unfettered to the pool.

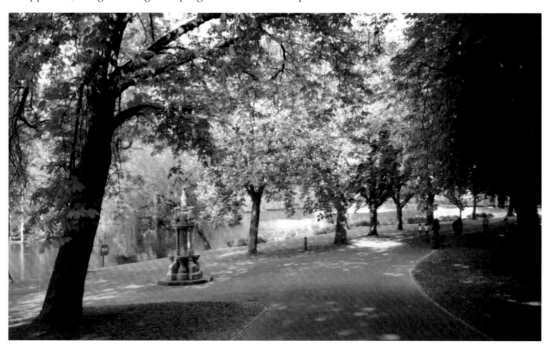

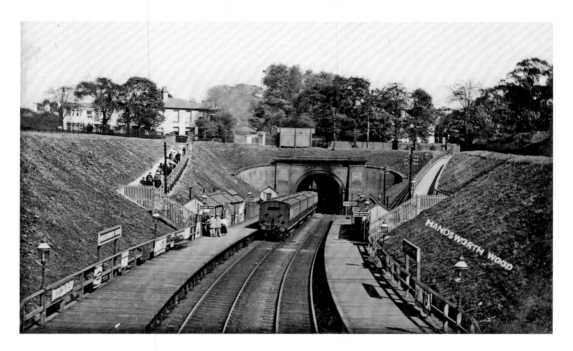

Handsworth Wood Railway Station

'Where have all the (commuters) gone....?' Well, they had all disappeared by 1941 when the station was closed, having been opened in 1896. The railway continues to bisect Handsworth Park by cuttings and an embankment. Both photographs were taken from a footbridge which still connects the two areas of the park. Access to the former station was provided in Hamstead Road.

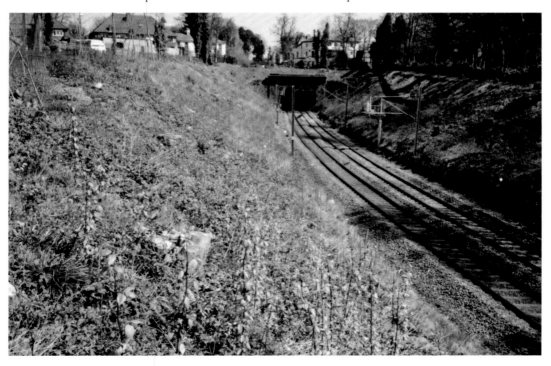

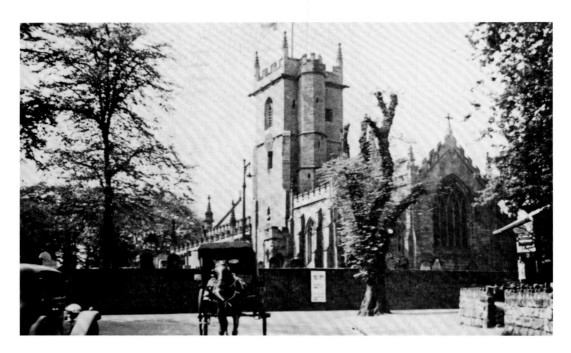

St Mary's Church, Hamstead Road

In earlier forms, this fine parish church dates back to the twelfth century. For much of its history, the church stood in relative isolation on the vast sprawling heath that constituted Handsworth from 'Hockley Brook to Sutton Park'. Within the church, Boulton, Watt and Murdoch were buried. Now, as then, a shop stands on the corner of Church Hill Road. 'Then' a bottle of pop, of Tizer, could be bought and 'now' a greater range of goods is on offer.

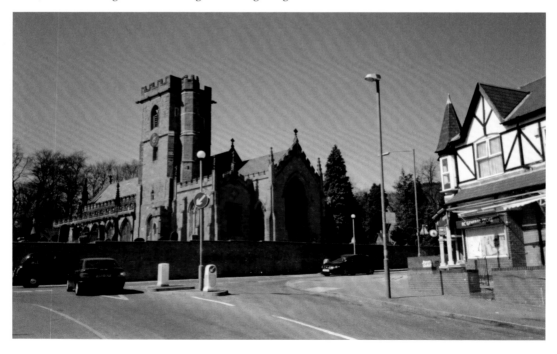

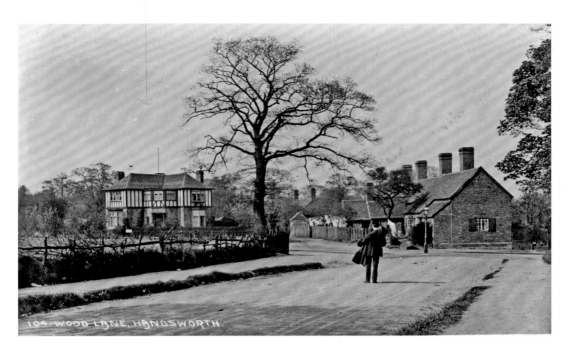

Wood Lane

A postcard written on 23 August 1910, George informing a pal, 'It's a very nice place to be with an armful of girl in the twi-twilight.' The last phrase is just a snatch from a popular ballad of the day, or earlier. The cottages ahead are thought to date back to the seventeenth century. All four cottages are now Grade II listed buildings.

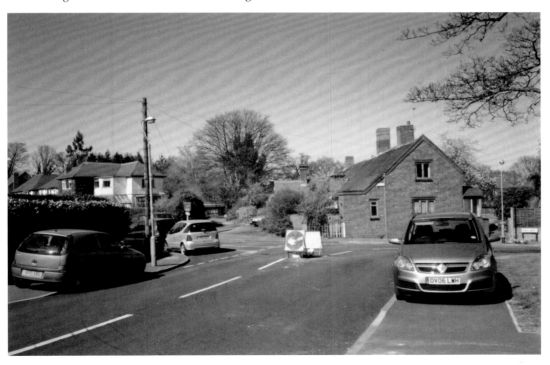

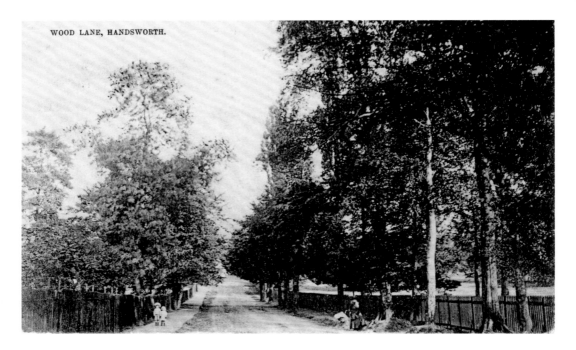

WOOD LANE, HANDSWORTH.

Wood Lane

The postcard (franked 1905) shows fields stretching away on both sides of the lane. In the distance, on the left but not visible, was located Lea Hall Farm, complete with duck pond. One of the authors, when a boy, caught sticklebacks from that pond. The farm became derelict and modern 1930s houses were built on the site and adjoining fields. As can be seen, a worthy attempt has been made to preserve something of the lane's earlier rural character.

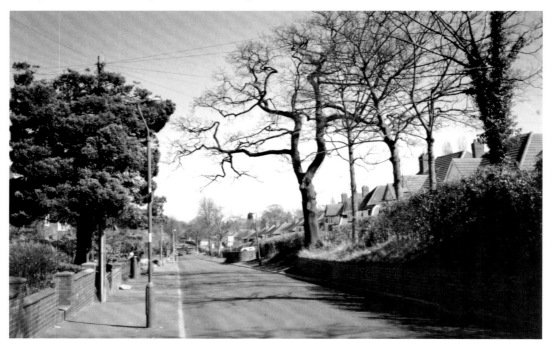

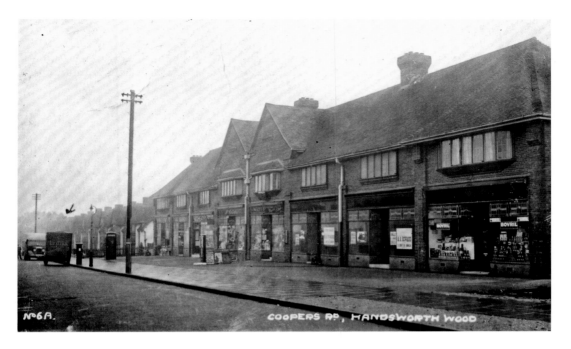

Coopers Road, Cherry Orchard

After Cherry Orchard farm, one of Handsworth's largest farms, was sold in 1930, the Cherry Orchard residential estate steadily came into being in the Handsworth Wood area. The postcard shows the shopping centre of the earlier development. Hand written notes are given on the back: 'Grocery, Chemist, Hardware, Drapers, Butchers, Confectionery & Post Office, Greengroceries'. While the overall structure of this shopping centre remains much the same after some seventy years plus of trading, current advertising is notably bolder and brasher.

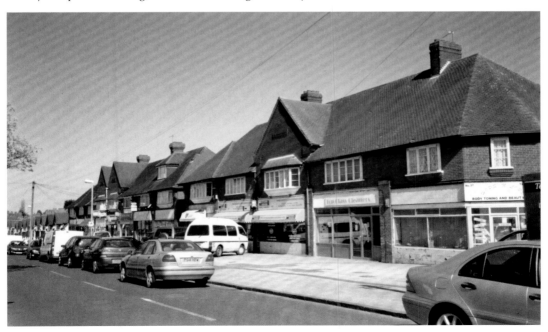

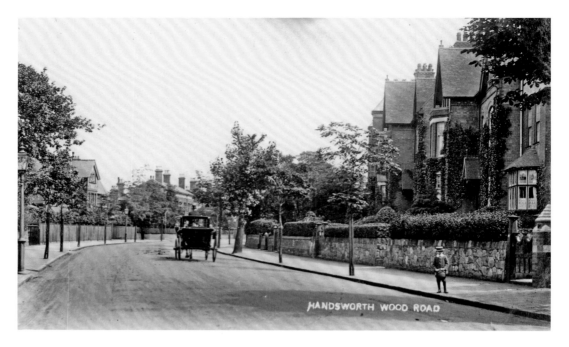

Handsworth Wood Road

An early twentieth century business or professional man who did not choose to live in Moseley or Edgbaston might well select Handsworth Wood for his home, in the road shown or nearby. The boy's attire, not least the straw hat and the top-hatted driver of the horse-drawn carriage, definitely point to affluence. Fine houses remain today but a rubbish skip here and there might prompt a closer look.

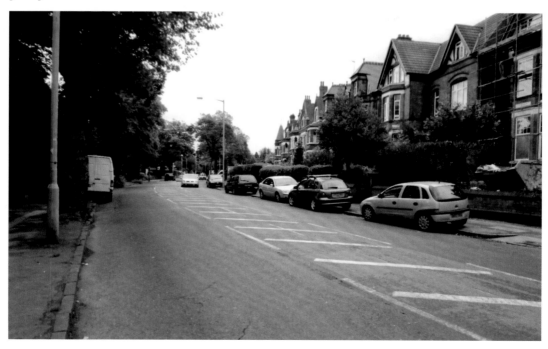

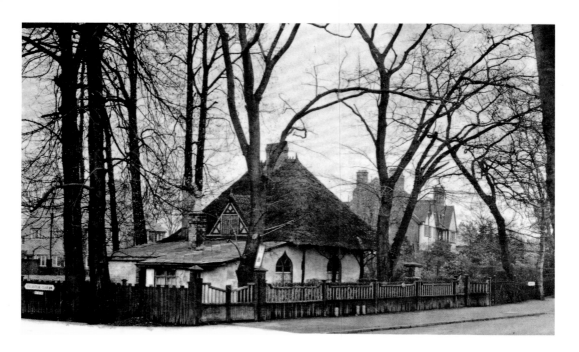

Handsworth Wood Road

This building is referred to as 'Lodge' or 'Gatehouse', a cottage serving the needs of a larger house nearby called 'Browns Green' originally built for a noted lawyer. Later, the house became a school, the lodge apparently serving as the tuck shop. The gatehouse survived the demolition of the house, but its thatched roof was replaced by tiles. Although nestling amongst trees, streams, not of water but traffic, rush by.

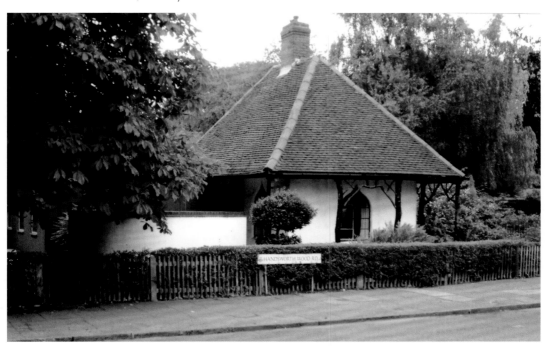

Friary Road

Set in grounds of 23 acres, this fine building, a Wesleyan Theological College was opened in 1881, to train would-be Methodist Ministers. On the back of the postcard, on 13 September 1912, a student writes; 'I have a study and bedroom to myself. There are 68 of us in residence. The 5 hours from 9am to 2pm are occupied in attending lectures.... The afternoon is spent in recreation from 2.45 to 5.15 & the evening study'. The building is now Grade II listed and along with much newer buildings forms part of a complex of halls of residence for Birmingham City University students.

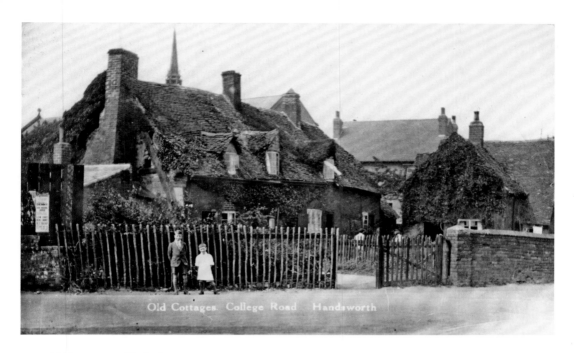

Old Cottages. College Road Handsworth

'Old Town Hall' Slack Lane

This now carefully renovated, venerable building offers great interest to historians and architects alike. Dating back to 1460, the building incorporates the rare cruck frame method of timber frame construction i.e. the use of naturally curved timbers as shown in the inset. For a period, the dwelling served as an occasional assize court and as the residence of the Parish Overseer. It is now open to the public and HQ of the Handsworth Historical Society.

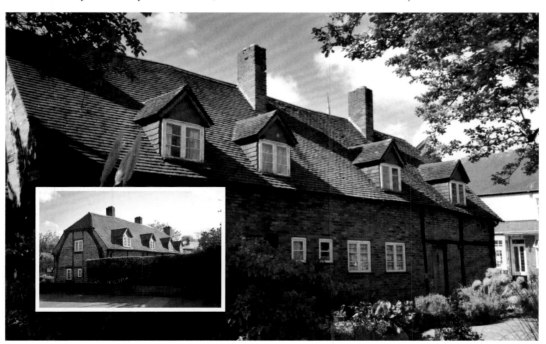

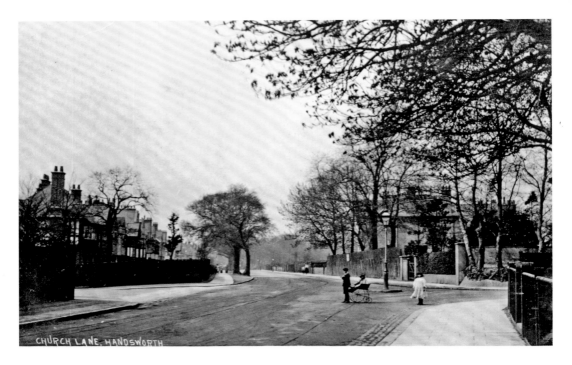

CHURCH LANE. HANDSWORTH

Crossroads, Handsworth Wood
Viewed from Wellington Road across to Church Lane with Hamstead Road left and Handsworth
Wood Road right. Changes are typical of many localities – a traffic roundabout for the travellers
and a high-rise building for would-be flat dwellers. In this particular case, buses have operated
along all four roads for well over half a century.

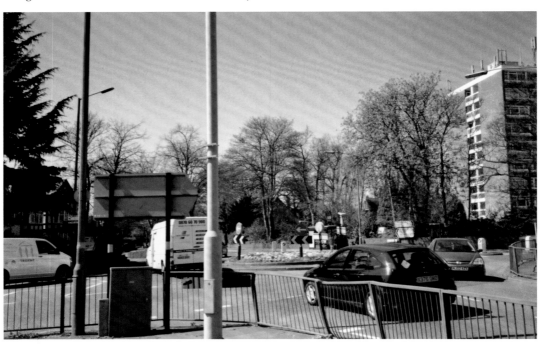

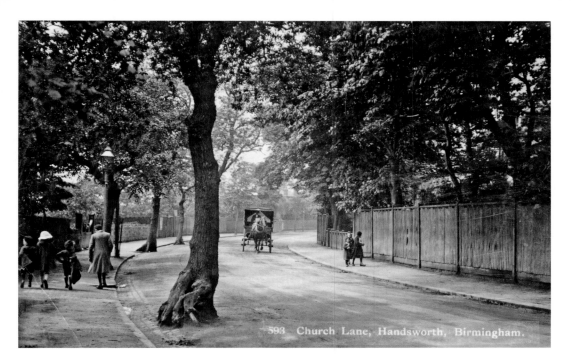

593 Church Lane, Handsworth, Birmingham.

Church Lane

For much of its length, Church Lane formed an elegant thoroughfare of spacious semis and fine, large detached properties shielded by high fences and mature trees. The breadman, the milkman and their kind would need to be on the lookout for 'Tradesmen Entry' signs. (Postcard franked 1918.) Schools are now to be found along the lane and at its far end a small supermarket.

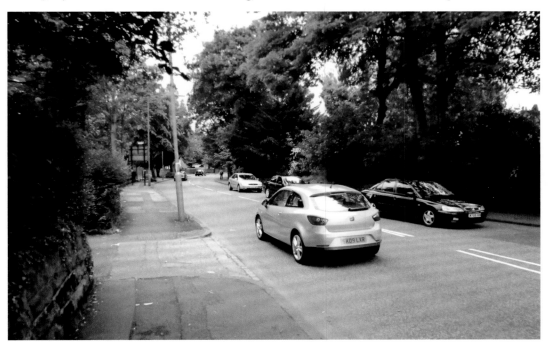

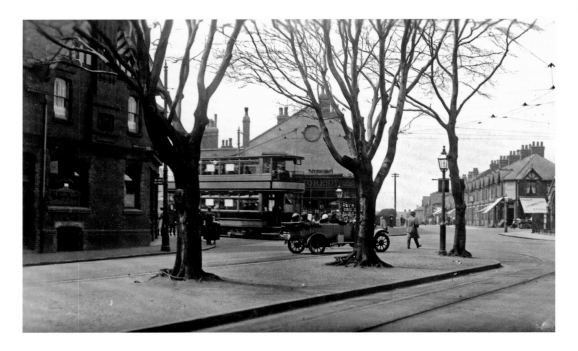

Grove Lane

Nearing its terminus, a 26 tram turns into Oxhill Road. The large, handsome car with probably a petrol can on its running board, may be heading for Church Lane. This part of Grove Lane was unusual for its short stretch of dual carriageway with a tram track either side. 'The Grove' refers to the large Ansells hotel-public house left, dating from 1891. (Postcard franked 1927.) The pub has moved in the cosmopolitan direction, serving 'then and now' through advertising: 'International Bar-B-Que, Traditional Ales, Large screen T.V.'

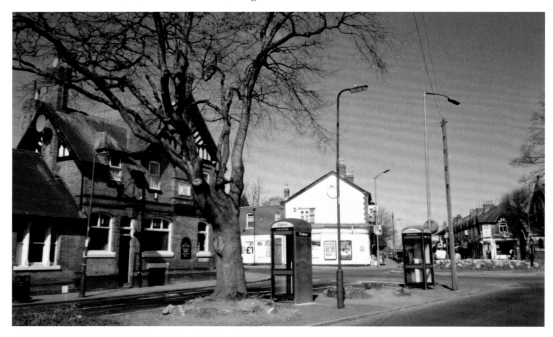

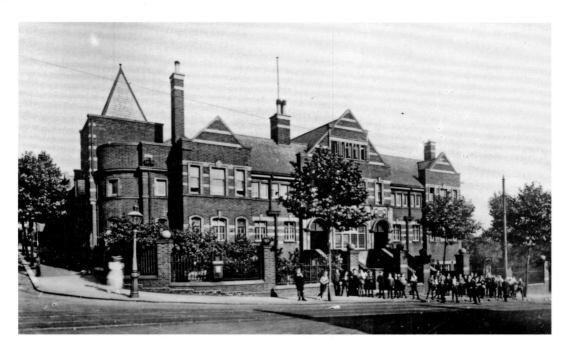

Grove Lane Public Baths

The above building, opened in 1907, proved to be a boon to swimmers and bathers alike. Relatively few houses had bathrooms at the time. First- and second-class swimming baths were available, twenty-three washing baths and one Turkish Bath. Women passed through one arched entrance, left, and men the other. The baths were very popular with schools and regularly used for water polo and swimming galas. The frontage of this fine historic building has been retained with new residential properties built behind.

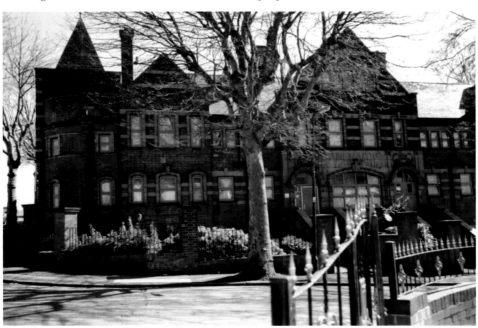

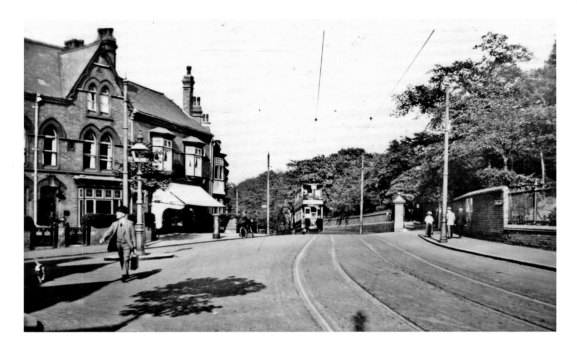

Grove Lane

The pillar right, forms part of a smaller gated entrance into the park. The tram is moving downhill in the direction of the baths. A smartly dressed white-collar worker, (waistcoat, tie and bowler hat) glances down Douglas Road. Now, behind the trees and park railings right, can be seen part of the Leviathan sized leisure centre, incorporating swimming baths, sports hall, sauna and steam suite facilities.

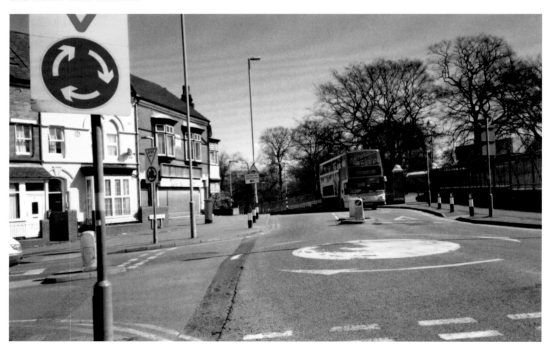

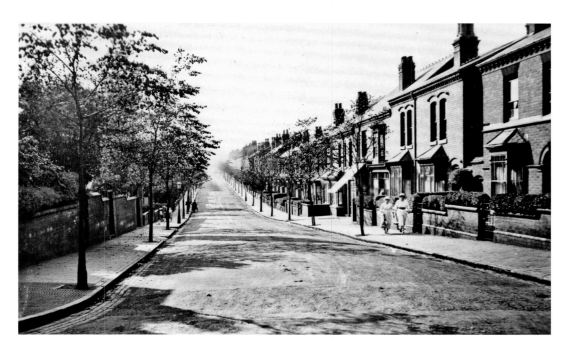

Douglas Road

A present day resident of this road might well wonder how things looked between the wars. Douglas Road was typical of many in the suburb. Houses are neat and tidy in exterior appearance without looking barrack like. Popular low brick walls are backed by clipped privet hedges. No vehicles, not even a handcart to be seen, and only one shop. Postcard franked 1930.

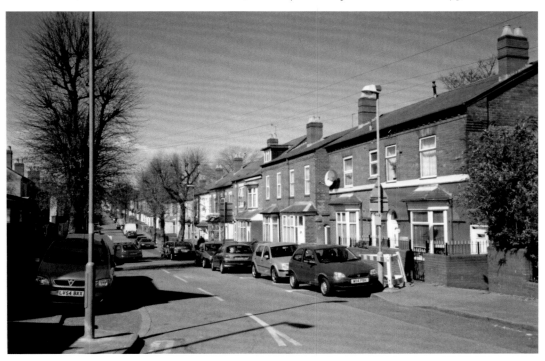

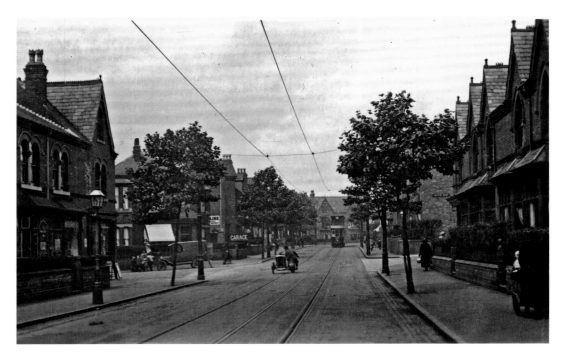

Grove Lane

Here is another example of the 'once a corner shop, always a corner shop' phenomenon. But the skip has replaced handcart and horse-drawn cart as indicators that work and change are under way. On the postcard, the motorcyclist is steering clear of the tramlines because if a wheel caught awkwardly in a rail, problems could arise. Cyclists on two wheels ran a greater risk.

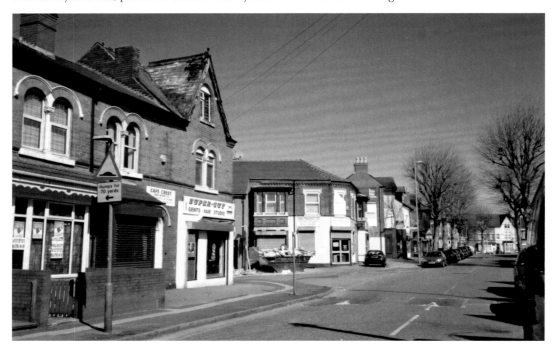

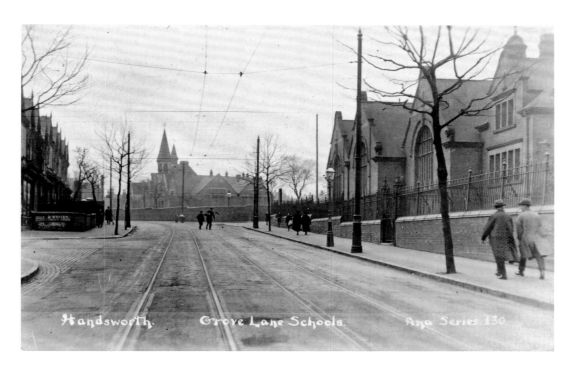

Handsworth. Grove Lane Schools. Ano Series 130

Grove Lane Schools

The nearer school was built in 1903 for the local council and subsequently reorganised several times regarding its pupil intake. Dawson Road forks right with the tramlines curving left as they near Soho Road. The distant school is the Handsworth Grammar School for Boys, a building opened in 1862 with a school roll of fifty-nine. At a glance, the schools have changed little in outward appearance, but indoors, teaching and learning have changed dramatically.

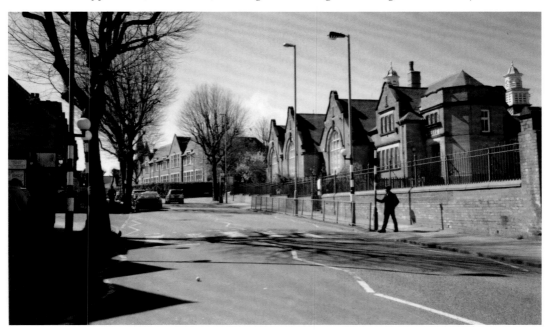

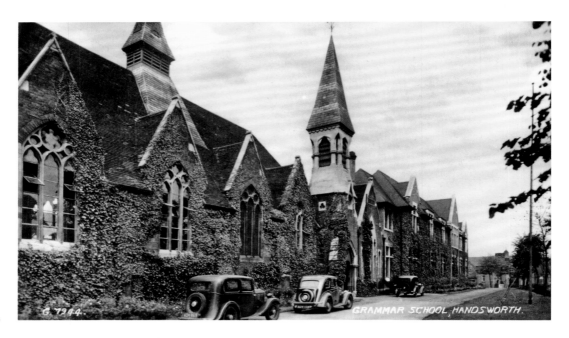

Handsworth Grammar School

With more durable bridges being built during the nineteenth century, money set aside for bridge repairs was used to establish the Bridge Trust Fund and the founding of this school. The school's badge reflects that history. On a black background the iconic zigzag bridge at Perry Barr is depicted in old gold colour, surmounted by the Staffordshire knot, also in gold. Today, this boys' school has nearly 1,000 students and a large sixth form which includes girls. The school also enjoys the status of 'Specialist Mathematics and Computing School.' (P.S. on the postcard back, Miss C. M. Dingley writes to a nephew, 'this is my school ...' where she taught for many years being held in great respect by first formers for her excellent teaching of English.)

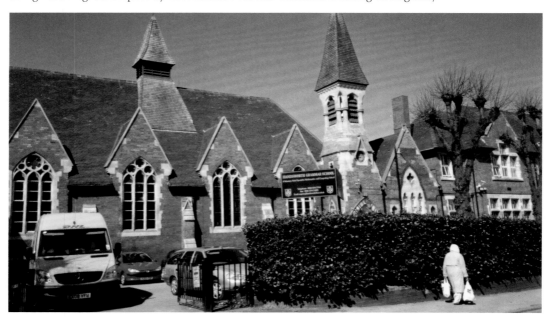

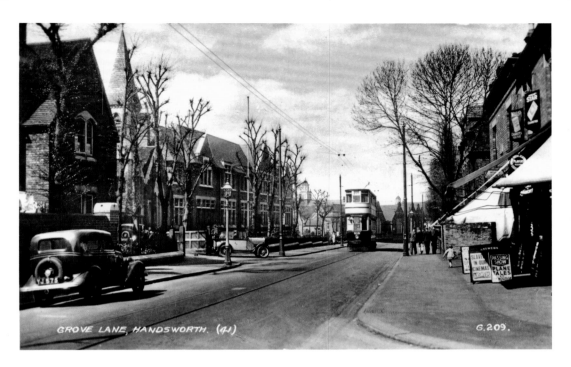

GROVE LANE, HANDSWORTH. (41)

G.209.

Grove Lane

Another postcard suggests that some teachers now come to work by car. Two popular magazines right, vie for public attention. 'Passing Show' introduces a pun, 'Plane Tales by...?' 'Answers' declares, 'Slavery in our Cinemas', an allusion perhaps to the pay and conditions of cinema staff? On the same pavement, there is now an advert for the sale of 'Halal Meat and Poultry'.

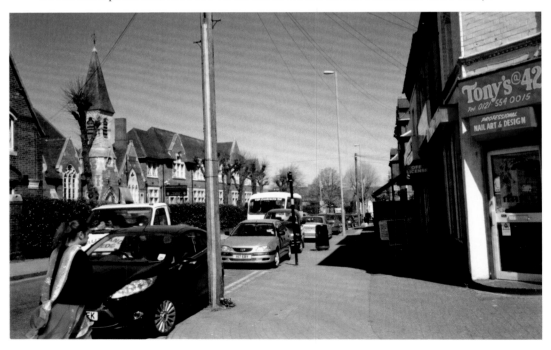

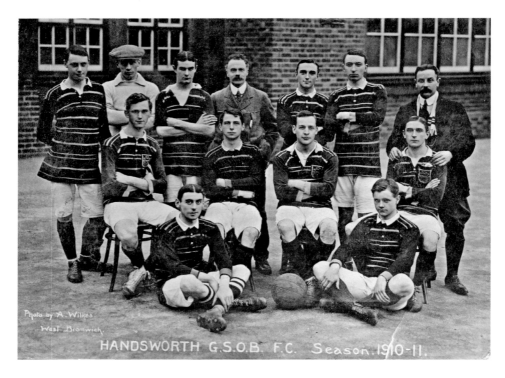

Photo by A. Wilkes
West Bromwich.

HANDSWORTH G.S.O.B. F.C. Season. 1910-11.

Handsworth Grammar School Old Boys' Football Club

A club that was founded in 1893 and still in being. While the main differences between the strips of the two teams are self-evident, the jerseys of the earlier team are black and gold hoops. Of course, flat caps for goalkeepers have long gone, along with the leather case ball, containing an inflated bladder, all drawn tight by leather laces. A very devil of a ball when sodden with rain and mud and totally unfit for the purpose of say, a Ronaldo.

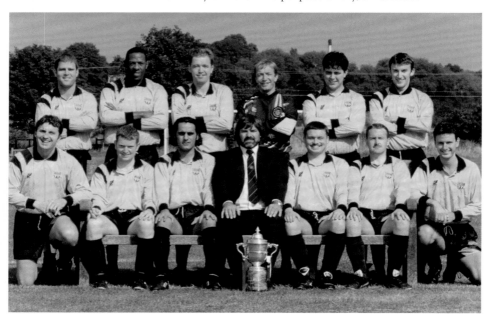

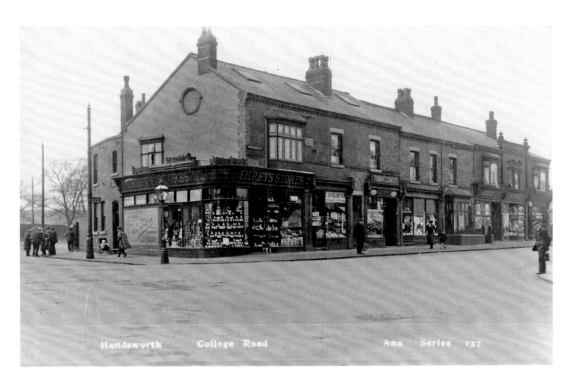

College Road

A commercial corner of the road adjoining Oxhill Road. Every ground floor seems to have goods to sell. The large corner shop is a branch of Ehrets stores, a local multiple grocers. A tobacconist's sign is plain to see. Two of the first four shops advertise off-licence facilities. Evidence from both photographs indicates that chimneystacks and pots were built to last!

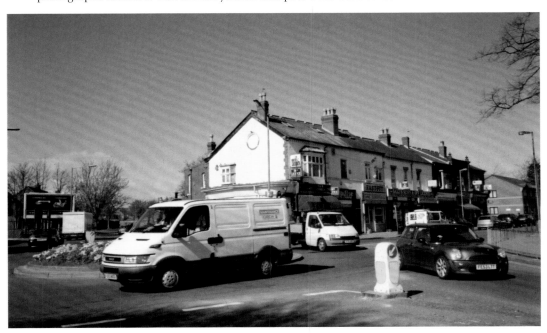

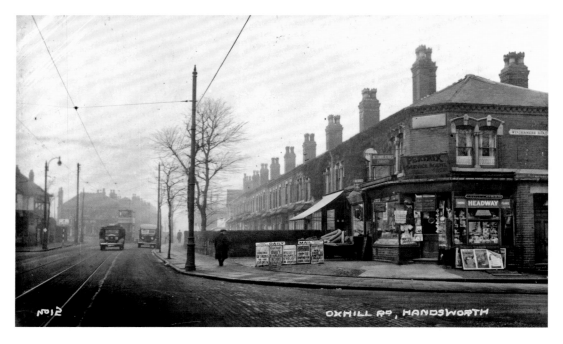

Oxhill Road

Hefty shutters at the corner of Windermere Road create quite a different impression from that of the scene of some seventy plus years ago. The old newsagents had much to sell and tell. 'Xmas Gift Books For Your Children', 'Mystery Of Injured Cyclist in Church', 'Cup Tie Coupons for Xmas Cash', 'Will there be another War?' That question suggests 1938 being the probable year of the postcard. This shop also sold Meccano.

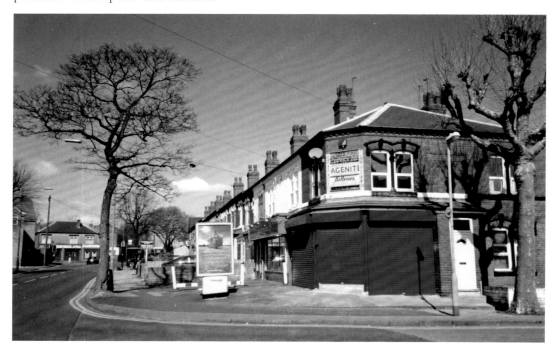

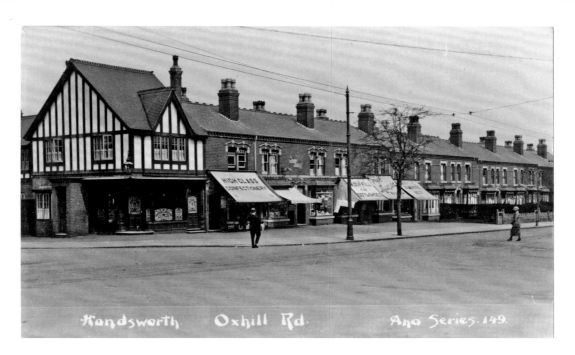

Oxhill Road

The black and white building at the corner of Stockwell Road is thought to be a public house or possibly an off-licence. To the right of the confectioners can be seen 'Duffill for Boots and Shoes', 'Meeson', (milliners?) and what surely is (à la mode) 'Beef'? Such signs would have been clear enough to top deck tram passengers – note overhead wiring. Steel shutters, and they are common, could be a present day signal that residents in certain areas are not fully at ease concerning their economic and social circumstances.

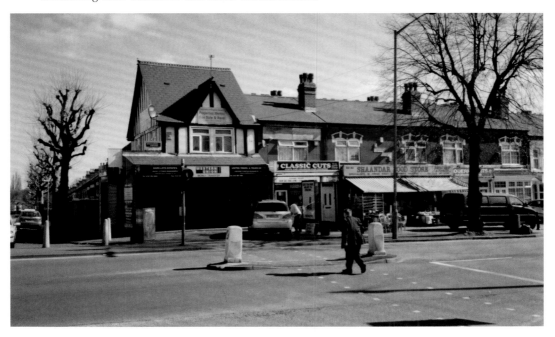

Oxhill Road

The grey, dispiriting aftermath, even under a blue sky, of demolition. Local residents seem uncertain about what might follow. In the past, the site served as an area of conviviality in the form of the Uplands Tavern. Built of brick, as were many large pubs of this period, and opened in 1932, becoming an M & B house.

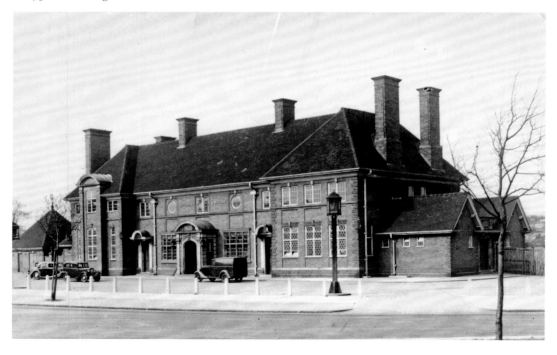

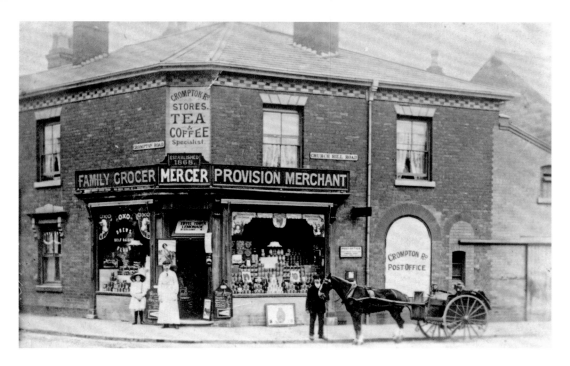

Crompton Road

An archetypal corner shop cum post office where, just above MERCER, can be read, 'Established 1868', a mere decade after the Crimean War. The left hand window advertises 'Drews Self-Raising Flour', a product from Drews Flour Mill just a few minutes walk away (see p. 82). Card franked 1911? Now the post office has gone and the chemist has moved to a busier neighbouring road.

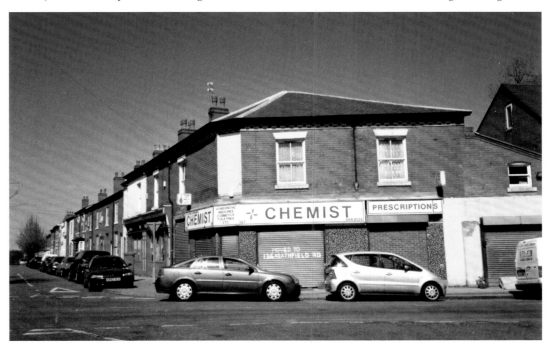

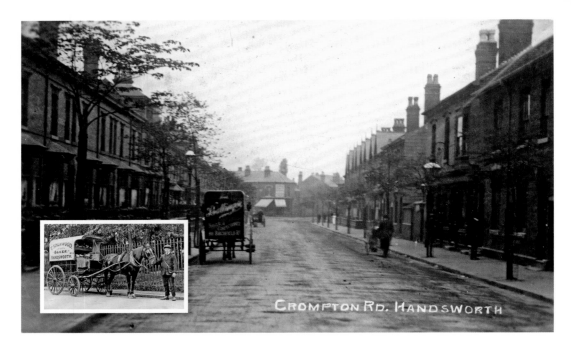

CROMPTON RD. HANDSWORTH

Crompton Road

Old houses have been admirably spruced up, new attractive residential property has been built, but the Crompton Arms pub is no more. The 'No Parking' sign would not have been seen by the driver of the horse-drawn van from 'Baker and Confectioner 99 Birchfield Road' (see back of van). Postcard franked 1915 when, and for years later, bread and milk were delivered daily to residents' doorsteps.

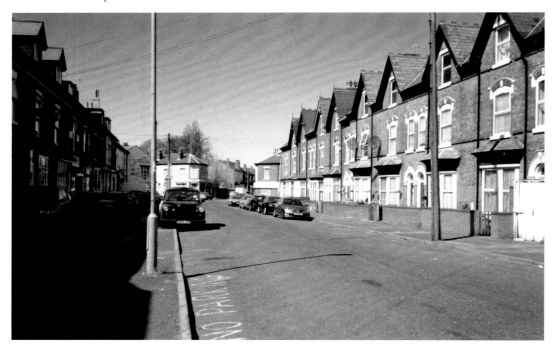

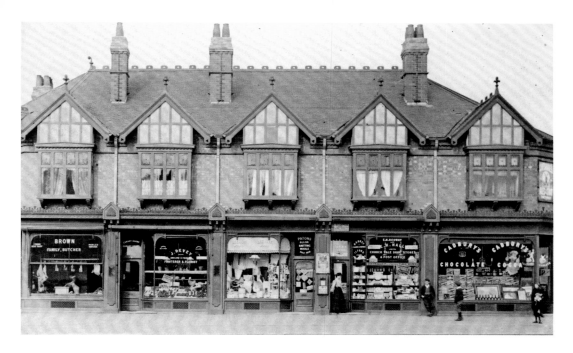

Church Vale

Cars apart, several points of broad similarity can be seen between the two photographs, a century apart. Present-day advertising appears bolder and more strongly colourful than the prevailing white lettering of the old days, e.g. 'Patons Alloa Knitting Wools'. Remarkably, the post office remains in business. Pre First World War, a well known French balloonist lived in Wilton Road, just left of the shops. When annual flower shows were held in Handsworth Park, M. Lempriere took paying passengers for joyrides.

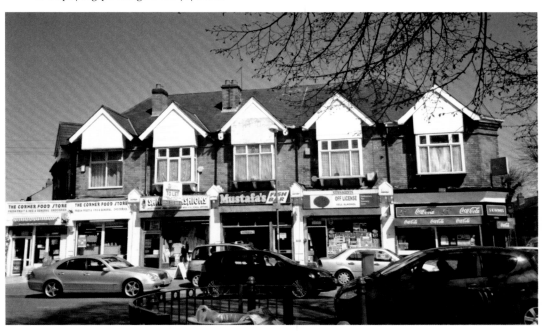

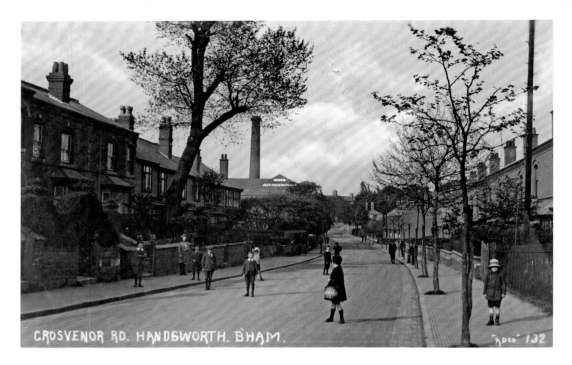

Grosvenor Road

In the distance, Grosvenor Road runs into Wellington Road in the Perry Barr direction. As at p. 79 the advertising emphasis is on self-raising flour, a boon to housewives and bakers as distinct from plain flour. The flour mill has been replaced by modern housing, including 'Mill Court', and saplings have prospered!

Westminster Road Church

This fine Congregational Church, dating from 1882, stood at the corner of Livingstone Road. It was strongly supported for many years and a well-equipped social centre was built to honour the fallen of the First World War. During the Second World War, ninety-six men and women served in the armed forces. While the main body of the church and its steeple have been demolished, the original adjoining church hall has been well maintained, serving as 'The Redeemed Christian Church of God', characterised by 'services, special events' and 'Salvation Theatre'.

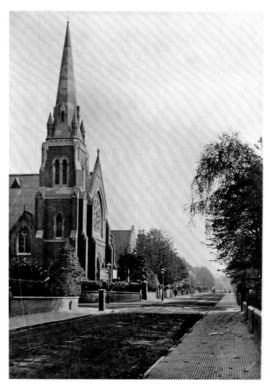

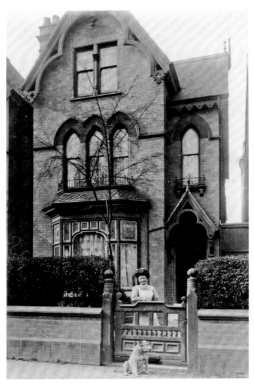

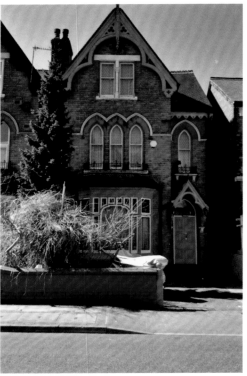

Livingstone Road

On the postcard is written, '17 Livingstone Road, Birchfield, Birmingham March 1908 to end of May 1909'. Written by the mistress of the house, or a maid in service? Many such houses would have employed domestic servants during this period. Neighbouring houses of this type have been converted into flats. At No. 17 a motorbike is being carefully sheltered from the elements.

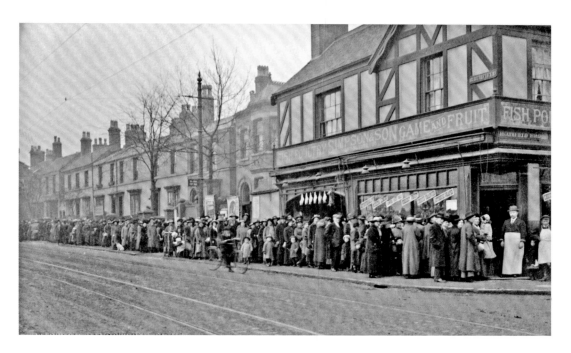

Birchfield Road

Along Birchfield Road people queue patiently for a ration of potatoes during the First World War. Simpsons Corner, as it was known, stood at the corner of Heathfield Road. The later view, taken from Trinity Road, shows a section of Heathfield Road having a short dual carriageway. The 'game, fruit, fish, poultry' shop has been replaced by tarmac, a low grassy bank and two bits of hedges. As is usually the case, the flyover looks obtrusive – if useful.

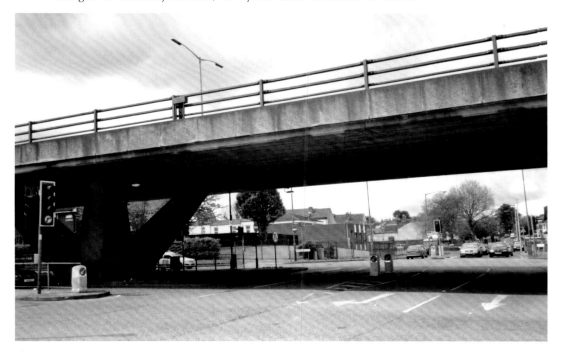

Birchfield Road

On the back of the postcard is written, 'Middleton 257 Birchfield Road, Birmingham 20'. A number of houses of this size and quality could be seen on either side of the road between Haughton and Livingstone and Canterbury Roads. Now, this house, stripped of its ivy, has lost a large part of its front garden to road development, six (or is it seven?) lanes of traffic stretching between 257 and the opposite side of the road.

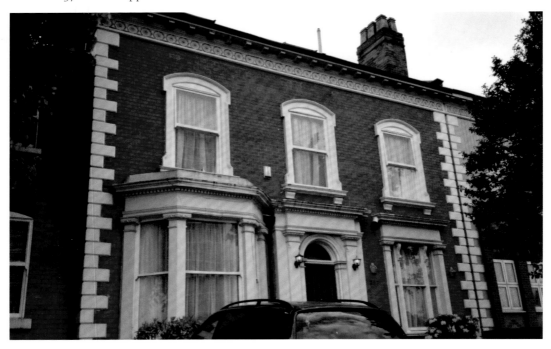

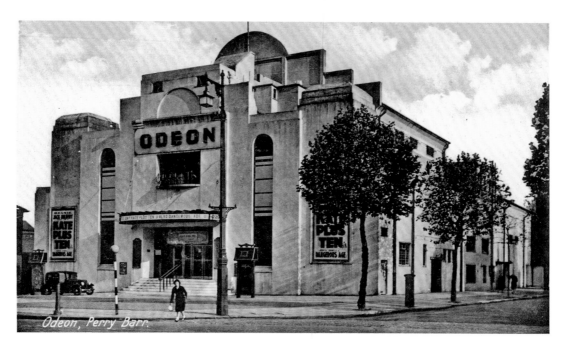

Odeon Cinema – Birchfield Road

This attention grabbing, uniquely designed building was the first Odeon cinema in the country (1930) and the first of what became Oscar Deutsch's circuit which eventually numbered nearly 300 cinemas. The supporting film *Dangerous Age* could be regarded as somewhat prophetic, as in 1940 a UXB (unexploded bomb) lodged in the building's foundations. The frontage of the cinema was later rebuilt in the form shown below, later becoming a bingo hall and now, as shown.

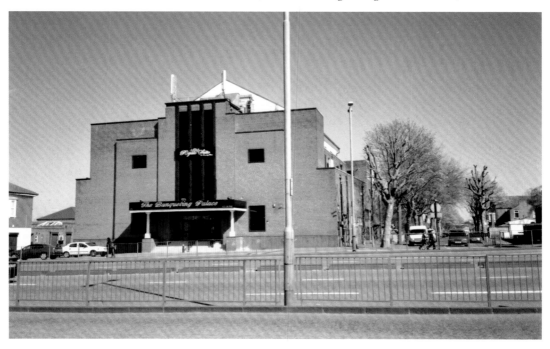

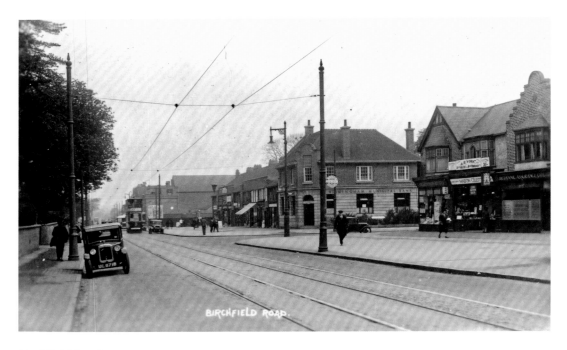

Birchfield Road

A relatively short distance lies between two cinemas – the Birchfield by the tram, with the Odeon just off the card to the right. On the corner of the Broadway stands a branch of the highly successful Birmingham Municipal Bank, the first such bank in the country. Lloyds TSB is now the corner bank, the broad pavement remains but new totems of today, 'Subway' and 'Internet Café' are well to the fore.

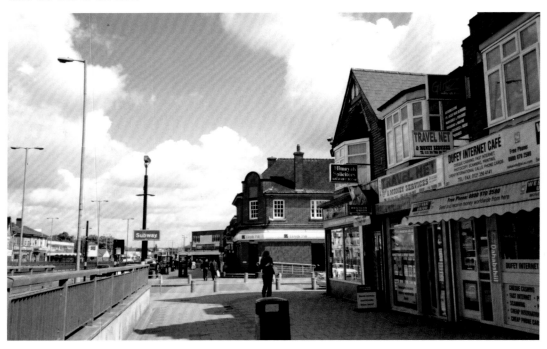

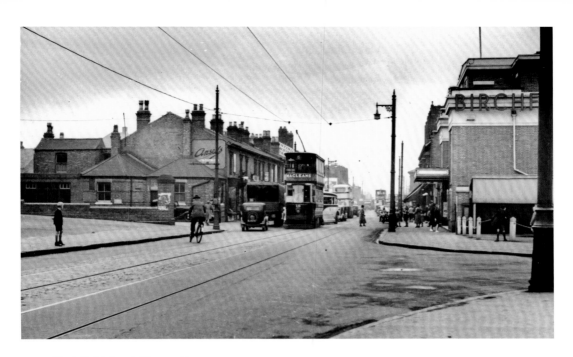

Birchfield Road Picture House

At the corner of Bragg Road, a side view of the cinema can be seen, probably a photograph from the 1930s. Behind the low wall opposite, a drive leads to a tram depot which successively became tram/bus then a bus only depot. Macleans, on the tram, was a toothpaste with a nifty advertising question; 'Did you Maclean your teeth today?' Follow the angle from 'Pak' and the latest version of a Crown & Cushion pub comes into view.

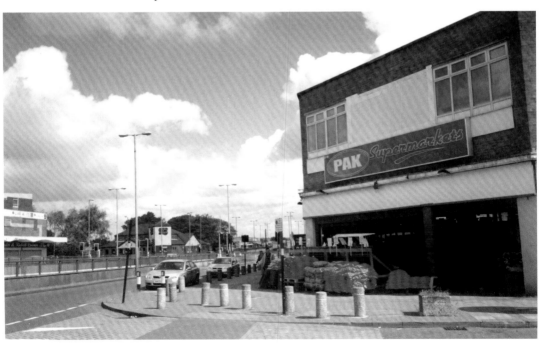

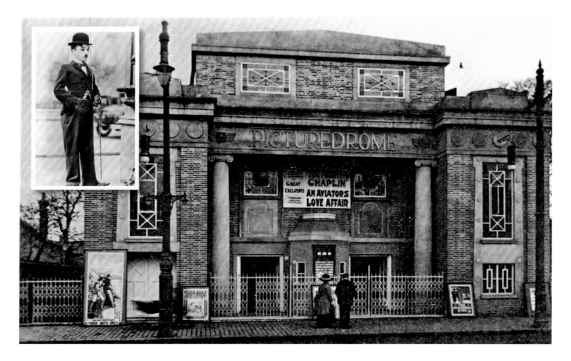

The Birchfield Cinema

The Picturedrome in Birchfield Road was opened in 1912 being renamed in 1923 as 'The Birchfield Picture House', 'The Birches' to local people. It was small, cosy and very popular. No doubt the cinema was packed for the Charlie Chaplin film. The cinema fell victim to the underpass road development in Perry Barr in 1962. Below, a silver car can be seen emerging from below street level.

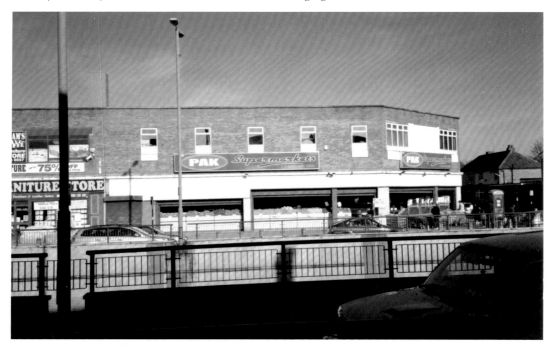

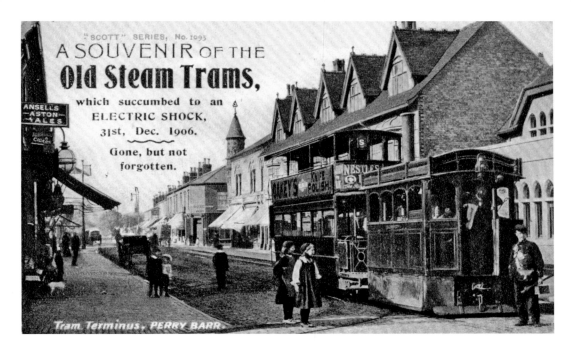

"SCOTT" SERIES, No. 1093

A SOUVENIR OF THE
Old Steam Trams,
which succumbed to an
ELECTRIC SHOCK,
31st, Dec. 1906.
**Gone, but not
forgotten.**

Tram Terminus, PERRY BARR.

Perry Barr Village

Because of the fumes, noise and soot particles it generated, the steam tram was dubbed 'the noisome beast'. Even so, on various routes in the Birmingham area, steam trams gave over twenty years' service. The Perry Barr service started in 1884, the public library (behind the conductor, right) being its terminus. The underpass development of the 1960s removed many familiar landmarks but it must have been in the vicinity of Adams Furniture Store that the 'beast' received its fatal shock.

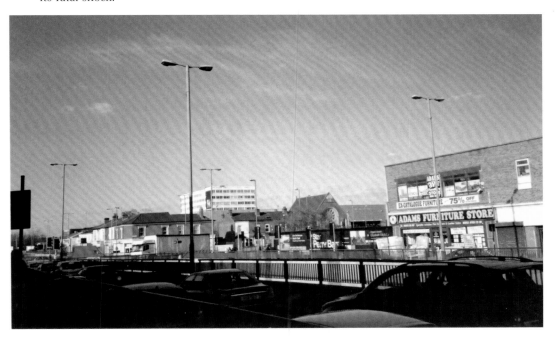

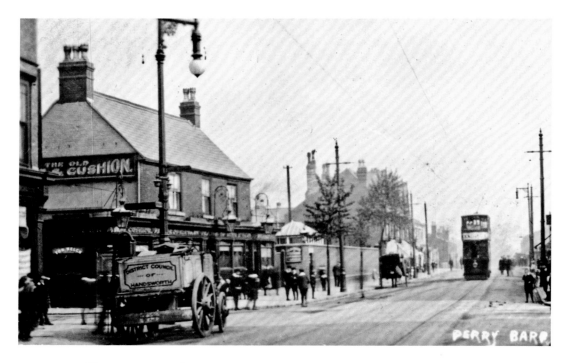

Perry Barr Village – Crossroads

A scene thought to date from around 1910 when Handsworth was still a Staffordshire town. By now, the tram terminus had been moved nearly to the end of Birchfield Road near the railway station. By the corner of Wellington Road is a water cart, for not every Handsworth household had a clean, piped water supply at the time. The old Crown & Cushion pub was replaced by a large, brick built pub in the 1930s and this, in turn, gave way to the pub shown.

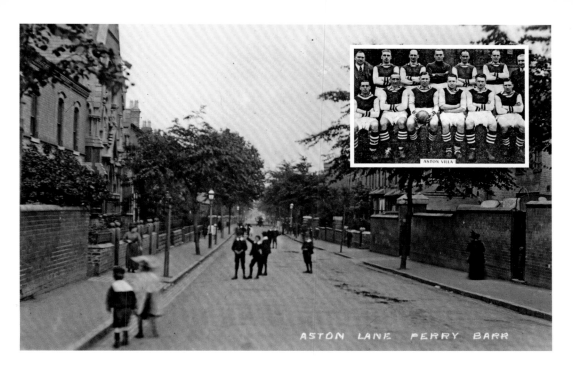

ASTON LANE PERRY BARR

Aston Lane

The postcard (franked 1912) shows the Perry Barr entrance to a long road that led to Witton, home to gigantic factories, Kynochs (later ICI), G.E.C. and to the ground of Aston Villa. These were the days when roads seemed almost as safe as pavements. The building, left, a better view is below, is Perry Barr Methodist Church, built in 1890 and still going strong offering various weekday activities in addition to Sunday services. The inset photograph shows Villa players of the 1930s and '40s.

Near Perry Barr Railway Station

Two car drivers have decided not to dive down into the underpass, railed off on their right. Beyond the railings can be seen the present Crown & Cushion. The shop left faces trading difficulties – note the loading restrictions sign and above the shop's own sign there lies a stretched coil of barbed wire. On the postcard, the tram is a No. 6 working between the city centre (Martineau Street) and Perry Barr village.

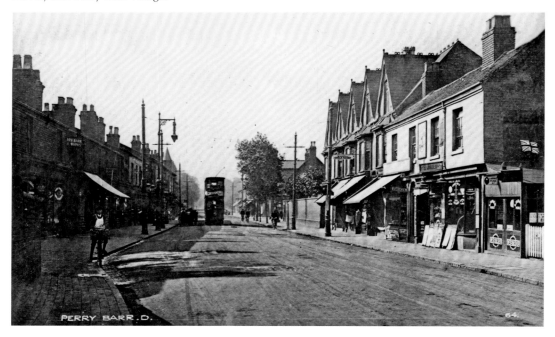

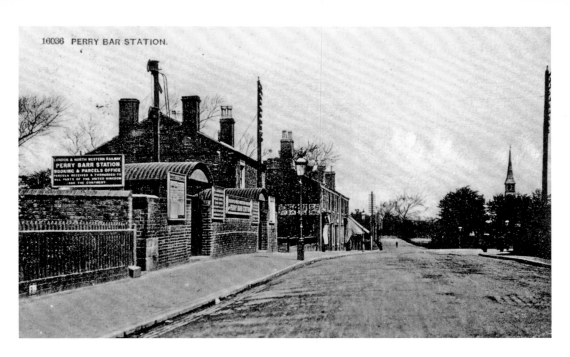

16036 PERRY BAR STATION.

Perry Barr Railway Station – Exterior
The Grand Junction Railway built this 1837 station which, according to some authorities, should have been named 'Handsworth'. The present entrance, below, could hardly appear more forlorn and undistinguished, sandwiched as it is between a charity shop and 'Royal Palms Caribbean Take Away & Delivery'.

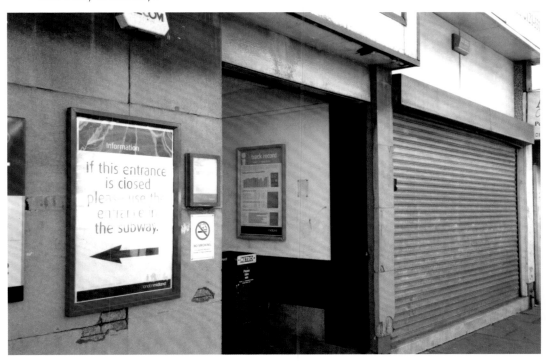

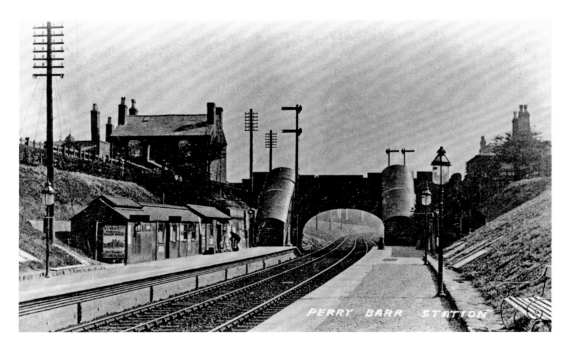

Perry Barr Railway Station – Interior

The postcard above is thought to date from the mid 1920s. A few years later, this railway service would be helpful to fans of greyhound and speedway racing, and athletics, as various tracks and stadia were built in the vicinity. Nowadays, steps down to the platform are uncovered and female guards tell the drivers when to go. (Yes, when, not where.) Bon Voyage!

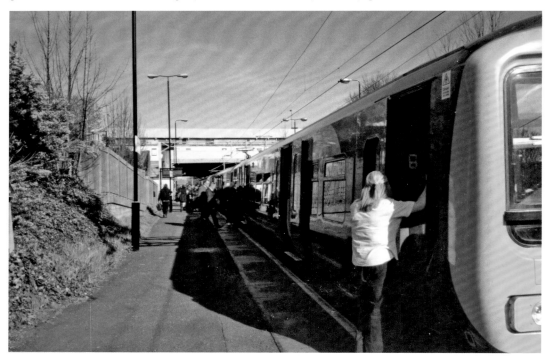